Fantastical Creatures Field Guide

Fanta
Crea
Field

HOW TO HUN
AND DRAW THE
AARON

WATSON-GUPTILL PUBLICATIONS/NEW YORK

stical
ures
Guide

THEM DOWN
WHERE THEY LIVE

LOPRESTI

FOREWORD BY WILLIAM STOUT

Editor: John A. Foster

Designer: Kapo Ng@A-Men Project

Production Manager: Sal Destro

First published in 2008 by Watson-Guptill Publications,

Nielsen Business Media, a division of The Nielsen Company

770 Broadway, New York, NY 10003

www.watsonguptill.com

Library of Congress Cataloging-in-Publication Data

Lopresti, Aaron.
 Fantastical creatures field guide: how to hunt them down and draw them where they live / Aaron Lopresti.
 p. cm.
 ISBN-13: 978-0-8230-1111-7
 ISBN-10: 0-8230-1111-9
 1. Fantasy in art. 2. Drawing—Technique. I. Title.
 NC825.F25.L67 2008
 743'.87—dc22
 2008001505

Watson-Guptill Publications books are available at special discounts when purchased in bulk for premiums and
sales promotions, as well as for fund-raising or educational use. Special editions or book excerpts can be
created to specification. For details, please contact the Special Sales Director at the address above.

Printed in China

First printing, 2008
1 2 3 4 5 6 7 / 14 13 12 11 10 09 08

To Shelley, Joshua, and Samantha, for their love and creative contributions to this book, and to Mom and Dad, for a lifetime of encouragement that has taken me this far.

CONTENTS

FOREWORD

I was deeply honored when Professor Aaron Lopresti approached me in regards to writing this foreword. The good professor and I have been friends for decades, despite a once bitter rivalry that neither of us knew about. We both share a passionate love of nature, particularly when it involves the more arcane aspects of urban and natural biology. We have journeyed together all over the terra firma, from the deepest bottoms of its abyssal seas to the far-flung tops of its frozen peaks. We risked our lives on a daily basis if only to obtain the briefest glimpses of the rarest of fauna and flora. As a result of our shared adventures, we have come to the same conclusion: The most fantastic and interesting creatures and peoples alive seem to thrive in the lesser known nooks and geographical crannies of our Planet Earth.

As a fellow artist and portrayer of All Things Organic, I can attest to the accuracy of Professor Lopresti's astute observations, both in his marvelous text and in his meticulously well-observed drawings. . . I was there.

Together, we witnessed all of these wild critters up close and dangerously personal. Did I ever tell you about the time we were trapped in the bottom of an inescapable hell pit, its walls covered in hyperslime, as unarmed we faced completely enraged giant, man-eating Gollychompers? But I digress...

Photographs could not do these animals better justice than Aaron's fine watercolors. I know that from firsthand experience. As Aaron merrily and feverishly sketched the denizens before our lucky eyes, I snapped away, alternating between the twelve cameras that hung from my neck. Click, click, click! Close-up! Click! Click! Click! Long shot! At the end of our quest, Professor Lopresti's labors resulted in bundles of beautiful studies, and I came home with rolls of film and digital memory cards packed with a vast series of colorful blurs. That, my friends, is the advantage that drawing has over photography—and why Aaron's delineations illustrate this book and my photos do not.

Artists tend to specialize. When Aaron and I roam the wilds of this globe, I tend toward drawing the dinosaurs, mammoths, and other prehistoric animals we encounter. The learned Lopresti is never more delighted than when we stumble upon an exotic hybrid of some sort—a link between our past and present faunas.

The two of us have the utmost respect for every one of these creatures—even the ones that smell really bad. Mother Gaia created them all, and like each of us, every animal is unique. Yet all of us, no matter who or what we are, share the same basic building blocks of DNA. It is the slightest of variations of those magical strands that make us people, for example, rather than some stinky Himalayan Ice Chuffer (future book). All of us share this magic stuff in our flesh, blood, bones, and hair (although I'm rapidly losing the stuff that's in my hair; but that makes for a great trail to retrace our steps during the many times we find ourselves lost). We are connected, not just in where we live, where we can travel, what we can touch, hold, see, taste, or smell, but in the most profound essence of what we are and what it means to be alive.

What I'm trying to pass on to you from what Aaron and I have learned while experiencing the myriad diversity of Earth's life is that we all need to be the best stewards of and caretakers to this unique ball of water, ice, rock, and mud we all live on, so that our grandchildren can make their own journeys to personally experience Saber-toothed Jackrabbits, Island Terrapins, Drooling Wolfhounds, and lions and tigers and bears—Oh, my!—before they become distant figments of our memory and imagination; before our offspring's offspring are restricted to knowing them solely from the pages of a book.

All backward thinkers, Unite!

William Stout
Pasadena, California

PREFACE

Before you begin reading this book, there are a couple of questions that need to be answered: (1) Who am I? (2) What the heck did I just buy? and (3) How did it all come about? All are reasonable and thought-provoking questions. . . well, reasonable anyway.

My name is Aaron Lopresti, and I have been a professional illustrator and comic book artist/writer for somewhere in the neighborhood of fifteen years (it's starting to look like an old neighborhood). I attended the world-renowned film school at the University of Southern California, where I learned a lot about filmmaking but very little about art. So it makes perfect sense that I then decided to pursue a career in art rather than filmmaking.

After college I returned to my home state of Oregon and joined a commercial art studio called Art Farm. It was there that I refined my self-taught art skills and became a full-fledged professional illustrator. A hard-fought but successful career in comics followed and eventually led to this book. My inspiration for the creatures you are about to encounter comes from so many sources that it would be impossible to list them all. Suffice to say, my love of dinosaurs and legends like the Loch Ness Monster and Bigfoot, along with a lifelong attraction to fantasy movies, literature, and art, all played a significant role when I was creating this book.

My hope is that you will be inspired to throw reality to the wind, set your imagination free, and abandon all sense of conventionality so that you, too, will be able to create your own fantasy world, one that is governed by only what *you* dictate and envision.

And finally, one last word of advice: Be sure to bring along your curiosity for the unusual and, most important, a sense of humor as your begin this fantastical adventure. . . as you've now officially entered *my* world.

HOW IT ALL BEGAN

It was the spring of 2003, four months after my thirty-ninth birthday. I remember it clearly because it was the last birthday that I actually counted. I was returning home from a Backward Thinkers Convention and decided to stop at a rest stop just outside of Olympia, Washington. Located next to the big state map (you know, the ones encased in Plexiglas that everyone draws on) there was a booth selling Bigfoot hand puppets. Although I was impressed with the craftsmanship of the puppets, it was the odd-looking gentleman haggling over the price of the puppets with the salesman that caught my attention. Anyone with that much passion for Bigfoot yet still keeps an eye for the economy was someone I wanted to meet.

I walked up to the man and started a cordial but fairly one-sided conversation with him. It wasn't until I mentioned the Loch Ness Monster (something that I probably do way too often) that his eyes lit up from behind his Coke-bottle glasses. He triumphantly announced his name as if everyone in the world should have known it: Professor Ham Fabricatini. I acted like I had heard of him before, so as not to hurt his feelings. He began to explain that he was a world famous researcher of strange, fantastic creatures and abnormal phenomena. When he found out I was an artist of similar ilk, he became even more excited. He quickly pulled me aside so we could talk in private (apparently the Bigfoot hand puppet salesman was eavesdropping).

Ham, as I called him—because I couldn't pronounce his last name—began telling me how he had traveled all over the world researching first-hand accounts from witnesses and scientists of bizarre and unusual creatures that were unknown to the world at large. He explained how he wanted to publish his findings. He needed an illustrator because his only visual records were blurry photographs and crude drawings (go figure). I quickly became intrigued, and we agreed to meet at his home near Vancouver, Washington, a week later.

I arrived at his home at the appointed time and found the place to be in shambles. The front door had been kicked in, and everything inside was strewn about as if there had been a great struggle. At first I thought that Ham had dug too deep with his research and had sadly paid the ultimate price with his life. Suddenly, he walked out of the back room, and I immediately realized that he was just a slob.

To my surprise, Ham informed me that he would immediately be leaving the country on another unrelated research project. He was very vague, but tax evasion did enter the conversation at one point. He handed over to me all of his research notes and journals that he had kept concerning the creatures and asked me to see that his book be completed. I took the notes and left his home with a growing sense of excitement and determination to see that the work of this brilliant man got published—and to take as much credit for it as possible. Unfortunately, I never saw Professor Ham Fabricatini again.

It took me over three years to create the illustrations and transcribe the journals into this book that you now hold in your hands. It is presented as a field guide of sorts, designed to take you on a journey through the continents and countries in which these little-known creatures dwell. I hope you enjoy the journey, and I hope that somewhere in the world, Professor Ham Fabricatini is smiling and not sitting in prison for tax evasion.

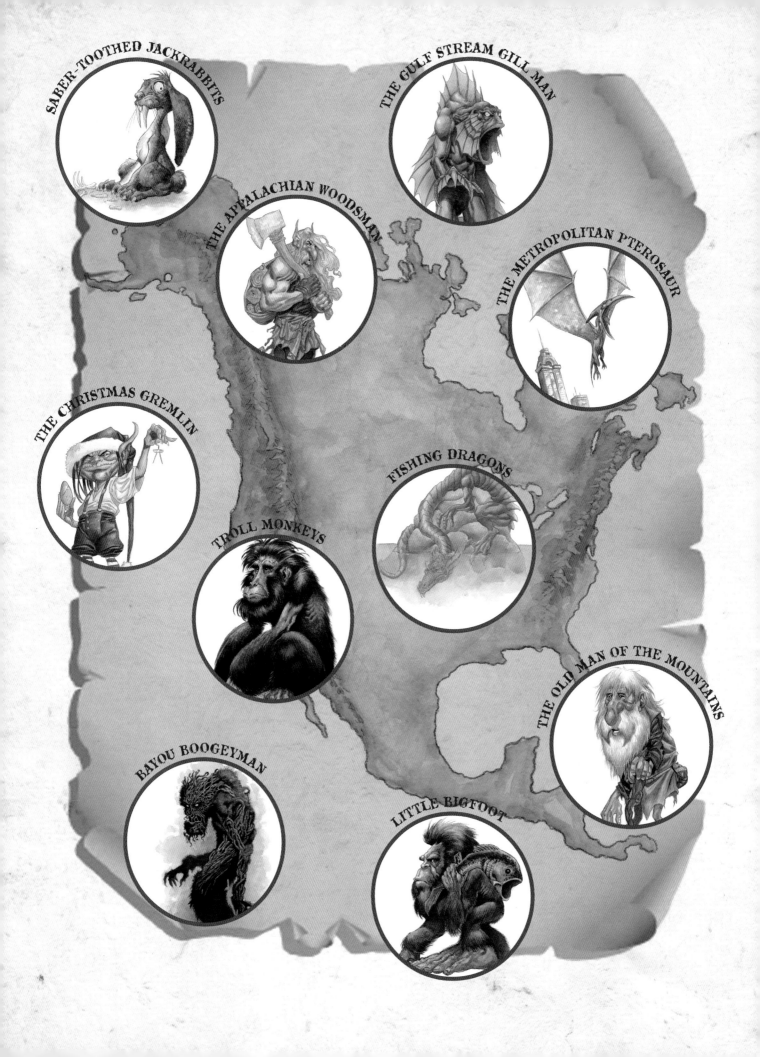

SABER-TOOTHED JACKRABBITS

THE GULF STREAM GILL MAN

THE APPALACHIAN WOODSMAN

THE METROPOLITAN PTEROSAUR

THE CHRISTMAS GREMLIN

FISHING DRAGONS

TROLL MONKEYS

THE OLD MAN OF THE MOUNTAINS

BAYOU BOOGEYMAN

LITTLE BIGFOOT

CHAPTER 1

NORTH AMERICA

Ham Fabricatini's personal journal entry 5/19/1998

I decided to start my search for the world's fantastical creatures in North America because I live here. After thirteen months of exhaustive research I discovered evidence of a wide variety of creatures, ranging from a flying pterosaur and swamp-prowling boogeyman to dragons fishing illegally in the lakes of our great country. I am amazed that these creatures can exist largely unnoticed in such a scientifically enlightened land. Perhaps our society is too easily distracted to. . . wait, is that a butterfly?

The self-proclaimed
explorer and
Metropolitan
Pterosaur expert,
Hubie Merphflaceter.

The Metropolitan
Pterosaur egg,
as described by
Merphflaceter.

The hind leg of the Metropolitan
Pterosaur is perfect for attacking and
carrying off unsuspecting civilians.

THE METROPOLITAN PTEROSAUR

CITIZENS OF NEW YORK CITY BEWARE! FLYING ATTACK DINOSAUR ON THE LOOSE.

Many urban legends exist about giant prehistoric flying reptiles nesting atop the world's highest skyscrapers, but could there be credence to these stories? During the early 1980s, several people reported being attacked in New York City's Central Park by giant flying birds. It was later discovered that the attacking "birds" were actually just kites, and that the people who were "attacked" were just plain stupid. Then, in the summer of 1989, several people, whom experts deemed intelligent, reported a man being carried away by what they described as a "giant, featherless bird." Confusingly, some reports read "giant, fatherless bird." Assuming that it would be impossible for the witnesses to know if the bird was fatherless or not, authorities later concluded the reports must have contained simple spelling errors.

As officials dug deeper into the mystery, however, a former South American explorer named Hubie Merphflaceter stepped forward with some astounding information. Merphflaceter claimed to have discovered a small colony of pterosaurs living deep in the Amazon jungle. Seeking fame and fortune, he stole one of the eggs and brought it back to his home in New York City. He incubated the egg, and within a couple of months a baby pterosaur hatched, which he named the Metropolitan Pterosaur. After weeks of trying to raise it and pass it off as his baby cousin, Merphflaceter finally turned it loose, as it was constantly trying to eat him. Apparently, the thought never occurred to him that by setting it free it would just try and eat someone else.

As this information slowly leaked to the public, it became clear that the government was going to cover up the situation as best it could. Conspiracy theorists now believe the government is using the creature to keep the population under control in New York City. It is believed that the pterosaur is currently nesting inside the Statue of Liberty's torch, which would explain why it is always closed.

The Woodsman's axe blade is made of a special elfin metal that resists wear and dulling.

A sample of the Appalachian Woodsman's custom wood flooring.

One of the Woodsman's hand-carved wooden lawn gnomes.

THE APPALACHIAN WOODSMAN

MYSTERIOUS WOODSMAN ONCE AGAIN SAVES LOST CAMPERS' LIVES, LEAVING BEHIND LAWN GNOME AS GIFT.

Nearly 200 years ago, a colonial family from West Virginia found themselves homeless as a result of the War of 1812. As they huddled together for warmth under the trees of the Appalachian Mountain Range, a giant woodsman stepped out from the gathering mist. Without saying a word, the bearded Samaritan started a fire for the family, provided them with food, and gave them 1,200 square feet of wood flooring for their next home. Then, with a nod of assurance, he vanished as mysteriously as he had appeared. And so was the first official encounter of the giant elfin creature that came to be known as the Appalachian Woodsman.

As the legend goes, the Appalachian Woodsman was born into a clan of normal-sized elves, but as he aged, he grew in size and strength until he dwarfed his fellow clansmen. He soon found his height to be a handicap, as he was too large to fit in the standard elfin home, and was constantly breaking furniture and stepping on friends and family. Since there was no professional basketball league, the Appalachian Woodsman took his seven-foot-tall-and-growing frame and ventured into the Appalachians to find his calling.

He soon discovered a talent for felling trees—even the mightiest oak or the loudest environmentalist could not withstand him. Unfazed by varying weather conditions, the Appalachian Woodsman soon began working year-round to supply both elves and local humans along the Appalachian Mountains with firewood and building supplies.

Unfortunately, over the years human progress has severely diminished the need for the Woodsman's skills and services. Nowadays, while he can still be found supplying his elfin brothers and sisters with firewood, the Woodsman has branched out and begun a budding hand-carved lawn gnome business. Although he is seen less and less, lost Appalachian campers can still count on a mysterious delivery of firewood and wood flooring in their time of need.

THE CHRISTMAS GREMLIN

LOCAL MAN ACCUSES CHRISTMAS GREMLIN OF PURPOSELY TANGLING HIS HOLIDAY LIGHTS. SAYS IT'S NOT THE FIRST TIME.

One of the more frustrating things that occur during the holiday season is unpacking Christmas decorations, finding missing hooks for the ornaments, and discovering broken or missing lightbulbs. How many times have perfectly wound extension cords and Christmas lights been removed from storage only to be found in a tangled mess? This is not the result of poor packing, but rather from the dastardly work of the Christmas Gremlin.

This magical creature is most active during the weeks before Christmas, creeping around garages and closets in search of Christmas decorations to sabotage. In many ways the creature is the anti–Santa Claus.

Even though there is only one Christmas Gremlin, he manages to make his way around the world annually, wreaking havoc on every Christmas goody in sight. He will usually stay clear of homes in Idaho, because he doesn't like potatoes—unless they are twice baked, although most people don't have the time to prepare them that way since baking them once takes long enough.

The Christmas Gremlin never comes out on Christmas Eve, due to his fear of Santa Claus and his elves, which can be traced back to an altercation over a century ago when Santa caught the Gremlin torching the Christmas tree in the White House. When President Theodore Roosevelt walked into the room, he saw only Santa next to the burning tree. Sadly, Saint Nick took the fall, and after getting out of prison, he and his elves used the Gremlin as a toilet plunger for six months. Although the Christmas Gremlin has continued in his mean-spirited ways, he now stays clear of Santa—as well as indoor plumbing.

An angry Santa. Although a face that very few have ever seen, it is one that the Christmas Gremlin will never forget.

Santa's original toilet plunger, which the Christmas Gremlin personally replaced over a six-month period.

An even angrier Teddy Roosevelt, a face that Santa will never forget.

THE OLD MAN OF THE MOUNTAINS

SCIENTISTS SUSPECT "FRUIT BLINDNESS DISORDER" TO BE THE CAUSE BEHIND THE LEGEND OF YOUNG THOMAS APPLEBOTTOM.

The legend of the Old Man of the Mountains began over 250 years ago, when he was still a young lad of the hills. Just prior to the Revolutionary War, young Thomas Applebottom went exploring in the hills near his New England home. His mother, Wynonna Applebottom, told young Thomas not to come back without some berries for a pie. Thomas took his mother literally, and when he couldn't find any berries he decided to journey into the mountains to search farther and farther for the berries rather than go home empty handed. Eventually, he got lost and never returned home. (Later findings showed that Thomas tragically suffered from a rare disorder called "fruit blindness," which caused him to unknowingly pass by several berry patches.)

Thomas wandered aimlessly through the mountains for years and was kept alive by the kindness of the woodland creatures. They would bring him fruits and berries from the surrounding woods for him to eat. Of course, Thomas couldn't see the fruit, so he ate the animals instead. This went on for years because the animals apparently could never figure out what happened to their friends. Finally, Hal, the Great Spirit of the Mountains, appeared to Thomas and put a stop to this daily woodland creature buffet.

Hal turned the now-aging Thomas into an elemental being whose perpetual existence was powered by the strength and majesty of the very mountains where he dwelled. Once Thomas was no longer a threat to the local wildlife, Hal retreated to his winter vacation home in the Alps. Shortly after that, Thomas became known as the Old Man of the Mountains.

Thomas has since spent his time guiding lost travelers, mountain climbers, and explorers to safety. Legend has it that he once even guided lost American soldiers to Valley Forge—unfortunately, they were newly discharged and were looking for a pub near Boston Harbor. But as many historians will point out, he at least got them out of the mountains, a remarkable feat for a guy who has never been able to find his way out of the woods.

Wynonna Applebottom, who started the legend by sending her son out for berries that he was destined never to find.

Young Thomas Applebottom before he became the Old Man of the Mountains.

Thomas never found the blackberries because of his undiagnosed fruit blindness.

FISHING DRAGONS

LACKING COMPASSION FROM LOCAL FISHERMAN, DRAGON DROWNINGS ARE ON THE RISE THIS YEAR.

Fishing Dragons make their homes around the many heavily wooded mountain lakes of North America. The Fishing Dragon hibernates for most of the winter, but can readily be seen basking and fishing during the warmer spring and summer months. The dragons are especially active on the days after the lakes have been stocked with fish, which often leads to confrontations with the local recreational fishermen.

For centuries, the dragons stayed exclusively around the lakes fed by fresh mountain water. However, when word of man-made lakes spread, the Fishing Dragons formed fishing and camping clubs and soon began showing up in droves on the days the lakes were stocked. It didn't take long for the fishermen to become infuriated, watching the fish being snatched up by the dragons before they could bait their hooks. The most contentious issue seems to be that the Fishing Dragons do not have any catch restrictions and are not required to purchase fishing licenses—since they have no money, the idea seemed pointless. The dragons usually win any confrontations on account of their enormous size (15 to 25 feet in length), which makes it pretty hard to win an argument with one.

Ironically, Fishing Dragons can often be their own worst enemies, doomed by their own fishing techniques: They lie down along the shore with their heads submerged in the water, waiting to snatch a fish. But the dragons sometimes become fatigued after a long hike to the lake and fall asleep with their heads submerged. This leads to frequent dragon drownings, which prompt relentless ridicule from the fish—and certainly no compassion from the fishermen.

THE FISHING DRAGONS OUTDOOR SOCIAL CLUB

MEMBER SINCE 1984

PRESIDENT

A membership card for the Fishing Dragon's fishing and camping clubs.

An angry fisherman, who can usually be found at any lake where Fishing Dragons are present.

Fishing Dragons use their tails as an anchor line around trees or rocks to keep themselves from falling into the water while fishing.

The eyes of the Bayou Boogeyman are coated with a thin, transparent film that allows the creature to see underwater. Each eye consists of a single, giant pupil, which provides exceptional night vision.

Carl H. Rube was the first reported human to come into contact with the Bayou Boogeyman.

The Boogeyman's hands are similar to humans', in that they have four fingers and one thumb.

BAYOU BOOGEYMAN

TOWN BEGINS TO DOUBT THAT A "BAYOU BOOGEYMAN" ATE LOCAL PIG FARMER'S LIMB.

Pig farmer and moonshine entrepreneur Carl H. Rube first discovered one of these interesting creatures in 1974 while collecting swamp water for his moonshine still in the wilds of northern Louisiana.

Due to Rube's alleged drinking problem, he was dismissed at first by skeptics when presenting his finding to the press. However, Rube's tall tales of the "Bayou Boogeyman," as the creature was quickly dubbed, started to gain credibility when Rube would return from every trip to the swamp missing a limb.

The first official expedition to uncover the Bayou Boogeyman took place in the winter of 1976. Rube had initially planned to lead the expedition, but since the creature had already eaten both of his legs, walking seemed out of the question. Using Rube's map, the discovery expedition was able to locate and capture one of the creatures that measured 30 feet in length. They quickly determined that the creature's outer epidermis was composed entirely of organic vegetation, and additional research suggested that the creature functioned like a carnivorous animal. Unfortunately, the captured specimen was so completely saturated with water (and proved ineffective as firewood) that it was thrown back into the swamp before any more definitive scientific testing could be completed.

Further research has proven that although the creature's main diet consists of raccoons and opossum, it has no taste for human flesh. This fact has led experts to believe that the creature did not, in fact, eat Carl Rube's legs and arm, but rather he simply lost them. The nocturnal nature of the creature's prey also suggests that it, too, is nocturnal— or perhaps just a really late sleeper.

Their enormous size (up to 35 feet in length) suggests they have an amazingly long life span, similar to that of an oak tree. Sadly, even after many years, very little is known about the creature's reproductive habits. However, their small numbers suggest reproduction occurs rarely, if at all. Considering their horrific appearance, it is really no wonder.

Elmer "Red" Kneck.

The three-legged dog that was the only other witness to the Gulf Stream Gill Man.

Elmer's distant relative, Rosie Kneck.

THE GULF STREAM GILL MAN

PANAMA CITY MAN HAS A CLOSE ENCOUNTER WITH AN UNIDENTIFIED GILLED CREATURE. LOCAL PSYCHIC JOINS INVESTIGATION.

"The movie's real! The movie's real!" screamed Elmer "Red" Kneck, as he came charging naked out of the warm Gulf waters of northern Florida in September of 1957. The movie Elmer was referring to was the classic *Creature From the Black Lagoon.* Elmer apparently had had an encounter with a gilled man while diving for mud. At first his story was regarded as a wild hoax, but once Elmer calmed down and put some pants on, the people of Panama City started to listen.

It wasn't until the second sighting occurred in October of 1957 by a three-legged dog that the scientific community finally got involved. Although clearly the dog couldn't articulate what he saw, a local dog psychic was able to piece together a description that was uncannily similar to Elmer's. The psychic, Rosie Kneck, a distant relative of Elmer, found the dog to be truthful and genuinely terrified by the experience. The fact that neither the dog nor Elmer had ever met gave credence to both of their stories and allowed a scientific investigative team to be formed and financed.

Unfortunately, two days after setting out on November 29, 1957, the expedition was lost in an unseasonably late hurricane. The only object recovered from the wreck was the crew's tape recorder. Just one small sound byte was salvaged from the waterlogged tape that said, "Today, Smith saw . . . " Those haunting words are all that remain from the ill-fated expedition.

Some thirty years later, a new piece of credible evidence surfaced, supporting the existence of what locals have dubbed the Gulf Stream Gill Man. A black-and-white photograph was taken of the creature in 1987 on Halloween night near Kneck's Costume Shop. The photo clearly shows the creature handing out candy to local children. One child was quoted as saying, "He gave out full-size candy bars, but he smelled like fish."

Little Bigfoot's basic mud and stick hut is built at the foot of large pine trees. It is believed that this humble dwelling can house up to five Little Bigfoots.

The explorer Cal Fraudulenski is credited for discovering Little Bigfoot.

Scientists have concluded that the watermelon is Little Bigfoot's closest relative.

LITTLE BIGFOOT

INFAMOUS BIGFOOT HOAX FINALLY DEBUNKED. LOYAL SKEPTICS ARE ECSTATIC.

Countless Bigfoot skeptics raised their hands and shouted collectively, "We knew it!" when costume designer Phillip Morris admitted that he had made the Bigfoot gorilla suit for Patterson-Gimlin's legendary film clip of an unidentified subject—which the two men claimed was Bigfoot—walking in the woods on October 20, 1967. Fortunately, a group of steadfast Bigfoot believers kept looking for him, and it finally paid off . . .well, sort of.

In April of 1997, a research team led by Cal Fraudulenski literally stumbled over an apelike creature with huge feet that was fishing for trout in the coastal mountain forests of Oregon. Shockingly, this fully developed adult creature was no more than 36 inches tall. It didn't take Fraudulenski's team long to give the little creature the nickname Little Bigfoot.

Is this creature the legendary Sasquatch that has eluded human contact for decades? Cal Fraudulenski believes it is. Most people assumed that a creature which leaves a 17–20-inch footprint would almost certainly have to be very large. So why, then, is the Little Bigfoot so short in comparison? While researchers are still debating the answer to this fundamental question, many believe the creature's stunted growth is due to drinking coffee and smoking unfiltered cigarettes at a very early age.

The big question, however, is obvious: Is Little Bigfoot the missing link? While Fraudulenski's response of "I don't know what that means" has frustrated many believers, anthropologists, after months of testing, discovered to their surprise that the creature's closest relative is, in fact, the watermelon. However, the researchers caution that their findings could change after further tests have been conducted.

As scientists continue to study this creature, Little Bigfoot continues to live in his natural habitat, practicing a lifestyle that consists of trout fishing and hibernating in his little hut made from mud and sticks. Although he is currently being harassed by throngs of tourists and paparazzi, the bright side is that exposure to so many humans has made it much easier for the Little Bigfoot to acquire cigarettes and coffee.

A bunny prison cell often included only a stone for a bed and a hole in the ground for a toilet.

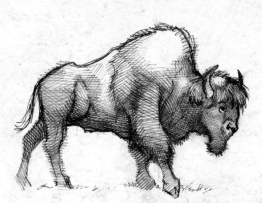

Buffalo were the favorite prey of the Saber-toothed Jackrabbit.

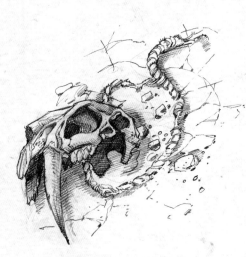

This skull of a Saber-toothed Jackrabbit lying in the remnants of a hangman's noose clearly shows the effectiveness of the rabbit posses.

SABER-TOOTHED JACKRABBITS

AS RUMORS OF A POSSIBLE PRAIRIE DOG POSSE CONTINUE TO SPREAD, SABER-TOOTHED JACKRABBITS BEGIN TO WORRY.

Saber-toothed Jackrabbits can best be described as nervous eaters. While all other rabbits are herbivores, Saber-toothed Jackrabbits are strictly carnivorous. The pursuit of a strictly protein diet seems to be its guilty pleasure. After every kill, the rabbit reacts as though it is afraid of being caught and prosecuted for a crime. Based on the history of the creature, its reaction may not be unwarranted.

In the mid-1800s, Saber-toothed Jackrabbits roamed the western plains of the United States in numbers approaching the millions. Their diet consisted of any small rodents they could find and, surprisingly, buffalo. Although small in stature, the Saber-toothed Jackrabbit packs quite a bite, and a small pack of these rabbits could easily bring down a mighty bovine.

However, as man moved west via the transcontinental railroad, a majority of the rabbits were indirectly killed. As settlers shot and killed buffalo from the trains for sport, the falling bodies of the bison crushed hundreds of thousands of hunting Saber-toothed Jackrabbits—a catastrophic example of being in the wrong place at the wrong time.

By the late 1890s the buffalo were nearly extinct, and the waning number of Saber-toothed Jackrabbits had to expand their dietary choices. Their new prey became the regular rabbit population. But it wasn't long before the regular rabbits formed posses to hunt down and apprehend the murderous Jackrabbits. Although some were thrown into the notoriously dangerous bunny prisons, many were hung to save taxpayers money.

So between long prison sentences, capital punishment, and being regularly crushed to death by buffalo carcasses, the Saber-toothed Jackrabbit population quickly diminished, and the survivors developed a real fear of . . . well, being caught. Today, Saber-toothed Jackrabbits are officially an endangered species, and as such are protected by the government—as long as they don't kill and eat any of the regular rabbit population. It is rumored, however, that the prairie dogs are starting to organize . . .

TROLL MONKEYS

LOU, THE FAMOUS CIRCUS SIDESHOW MONKEY, SENTENCED TO TEN YEARS WITHOUT PAROLE. RINGMASTER DEVASTATED.

Troll Monkeys are the only species of primates that are indigenous to North America. They live under stone bridges throughout the northeastern United States, much like their fictitious troll namesakes. The stream or river a bridge crosses provides the monkeys with effective outdoor plumbing—good for the monkeys, not so good for anyone living downstream.

The Troll Monkey's diet consisted mainly of peanuts, until growing societal awareness of food allergies forced them to expand their diet to include both soy and corn nuts. Troll Monkeys can often be seen just before dawn eating grass in open meadows. Researchers believe they do this to alleviate the constipation brought on by eating so many nuts.

The most telling incident involving a Troll Monkey occurred in 1929. While traveling through the Midwest, a French circus captured a Troll Monkey trying to bum cigarettes off one of the circus's performing monkeys. The proprietor of the circus thought the Troll Monkey was a hairy orphan boy, and quickly put him in a sideshow called L'Orphelin Poilu (the Hairy Orphan Boy).

Once it was discovered that the circus's newfound act was actually a Troll Monkey, the creature was arrested for fraudulently representing himself as a sideshow freak. The Troll Monkey, nicknamed Lou (no one really knows why), was convicted in a nationally publicized trial and sentenced to ten years in a Kansas correctional facility for impersonating an orphan. The creature served only three months of the sentence because it was decided that human laws should not really apply to animals.

A typical stone bridge that Troll Monkeys reside under.

The French circus chimp from whom "Lou," the Troll Monkey, bummed a cigarette.

The bummed cigarette.

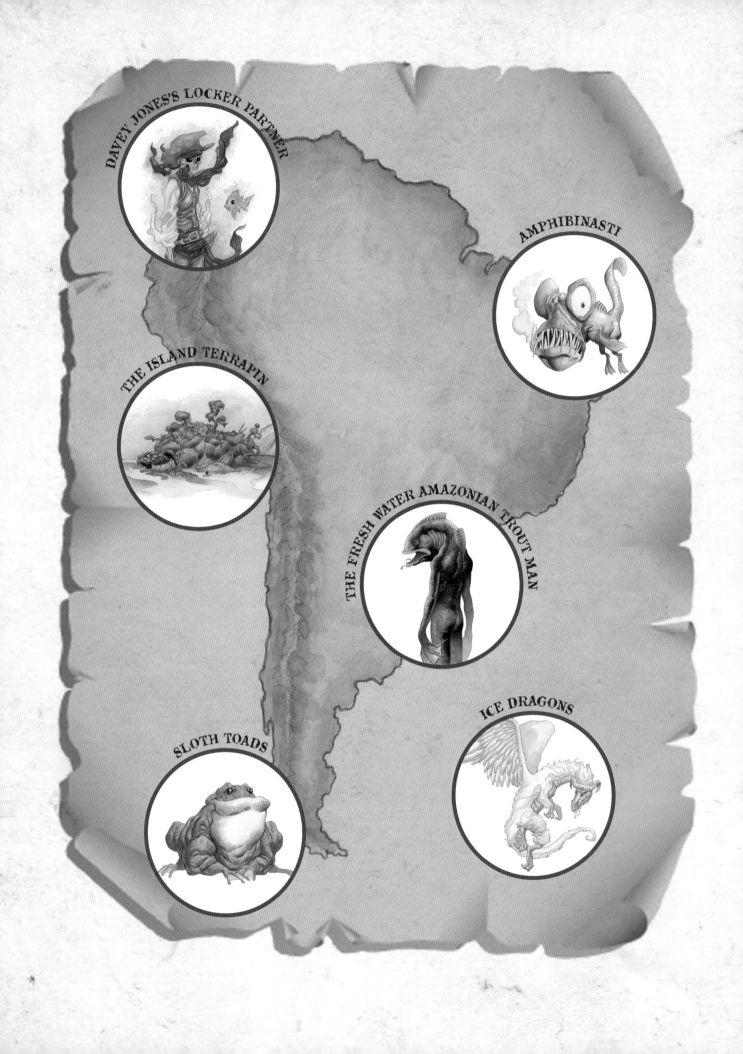

2

CHAPTER

SOUTH AMERICA

Ham Fabricatini's personal journal entry 9/19/1998

have been on the continent of South America for only six weeks, but already I have discovered several fantastical creatures and have contracted at least three diseases through mosquito bites. I knew I should have gotten those shots. So far I have encountered giant toads, huge turtles, and a nasty little water predator. Hopefully, I can uncover several others, including the mysterious Trout Man. I didn't know there were trout in South America . . . smells fishy to me.

Bob and Bobby Boynkins.

The mysterious
wristwatch
discovered in 1975
by the research
team.

The pencil the Boynkins
brothers fought over.

THE FRESH WATER AMAZONIAN TROUT MAN

ONE TWIN SWEARS HE WAS KILLED AND EATEN BY MYSTERIOUS CREATURE. OTHER TWIN IS WITNESS.

The first reported sighting of the Fresh Water Amazonian Trout Man was in 1963, by Bob and Bobby Boynkins, twin brothers from Arkansas. They claimed to have encountered the Trout Man during a hiking and fishing trip at Lake Lauacaca in Brazil. Since neither of them could correctly pronounce the name of the lake, nor had the resources to actually get there, their entire story lacked credibility. However, any scientific skepticism was soon laid to rest when the twins' mother stepped forward and proclaimed, "My boys are honest and would never lie, unless they felt like it." Interestingly, all subsequent sightings have been recorded solely by them. In one encounter, Bobby claims to have been killed and eaten by the creature. How he lived to recount the tale, however, still remains a mystery.

In fact, very little is known about the creature—well, actually nothing is known about the creature other than the stories told by the Boynkins. According to their oral accounts, the Fresh Water Amazonian Trout Man is anywhere from 18 inches to 12 feet long, and is often referred to as "the one that got away." The brothers have never photographed the elusive creature, and have only tried to produce a drawing of it once. However, the two ended up fighting over the pencil before they could finish the drawing.

Despite a complete lack of concrete evidence, a team of investigators went to Brazil in 1975. The team brought five sonar-equipped boats to conduct a thorough search in Lake Lauacaca for the creature. The expedition found nothing except a fifteen-year-old wristwatch clinging to a submerged tree branch near the center of the lake. Bob Boynkins said he thought it looked familiar, but was unable to completely confirm, being that he was asleep at the time. To this day, the research team has no idea to whom the watch belongs.

Recently, several scientific groups have reached the conclusion that the Fresh Water Amazonian Trout Man is actually a hoax, perpetrated either by the Boynkins or by whomever owns that watch.

DAVEY JONES'S LOCKER PARTNER

DECIDING TO PLACE OLD COLLEGE RIVALRIES BEHIND THEM, ORTHINIUS AND DAVEY ARE LOOKING FORWARD TO THEIR NEW PARTNERSHIP.

Davey Jones's Locker is the destination for all salty sea dogs who meet their demise on the high seas. As caretaker of the watery dead, Davey gets very little free time to enjoy the finer things in life and death. So when he just has to get away, who steps in to watch the captive spirits? Davey Jones's Locker Partner, of course.

Although Davey Jones's Locker partner, Orthinius Rosenblatt (or Bad Blatt the Pirate), has been around as long as Davey, he doesn't get the same recognition or notoriety. Their early days together at the Triton Academy of Death Management established the hierarchy between the two that still exists to this day. Davey Jones appeared to be the superior student, but regularly stole test answers from Orthinius and frequently upstaged him. Davey Jones's scheming and overt dishonesty were viewed as excellent career-building skills for death management at the academy, and the die (pardon the pun) was cast.

Because of his excellent poor performance at the academy, Davey Jones received an immediate commission from Triton upon graduation. Mort, of the less-renowned Mort's Locker, was retiring, and Triton felt Davey Jones was equipped to replace him. Davey, of course, chose Orthinius as his Locker partner, and their fates were forever sealed.

As the legend of Davey Jones grew, so did the obscurity of his Locker partner. Rumors are rampant throughout the community of the dead that Orthinius is really the one who has done all of the work, while Jones just took the credit. For instance, Orthinius is rumored to reward the lost souls with gold coins when they clean the Locker during Jones's vacations. Although Orthinius obviously has superior management and bookkeeping skills, it cannot be denied that Davey Jones's gift for deception has landed a large number of the Locker's restless souls. Regardless of how one looks at it, their partnership works—albeit the rewards are not equitably split. But then again, whoever said death was fair?

Triton, King of the Sea and founder of the Triton Academy of Death Management.

Orthinius Rosenblatt's small bag of gold coins, which he is rumored to use as incentive to the lost souls to keep the Locker tidy.

Mort, of the less-famous Mort's Locker.

Underwater vegetation used
for flossing can be hazardous
to the Amphibinasti.

A frightened, and
envious, piranha.

Stones surround a large
underwater nest of Amphibinasti
eggs to give extra protection.

AMPHIBINASTI

RARE SPECIES' ABILITY TO EAT ITSELF CONTINUES TO CONFOUND SCIENTISTS.

The South American Amphibinasti has terrifying looks and a nasty temperament to match. Even the notoriously vicious piranhas swim clear of this angry meat eater. It has been said that a school of piranhas can strip an elephant to the bone in a manner of minutes, but this pales in comparison to a ravenous Amphibinasti, which will strip itself in a matter of seconds if hungry enough. Although this usually ends up being its last meal, the respect and fear it elicits from the other animals seem to be worth the sacrifice.

If an Amphibinasti will eat itself, it most certainly will eat one of its own kind without any hesitation whatsoever, which explains why the creatures always travel alone. Some researchers have admitted it is possible that Amphibinasti could hypothetically travel in pairs, but they cannot say for sure, as one Amphibinasti could technically eat the other before anyone saw them together, leaving no witnesses to verify whether the Amphibinasti was alone the whole time or not.

Besides themselves, the Amphibinasti will eat anything that lives in or enters the water, which includes careless humans and the occasional wombat—although wombats don't live in South America, if they did, the Amphibinasti would most certainly eat them.

Although this tiny tyrant has no natural predators aside from itself, its long, spiky teeth provide a potentially fatal hazard for the Amphibinasti. Frequently, they become entangled in underwater vegetation while attempting to floss chunks of meat from their teeth. An immobile Amphibinasti will then quickly become waterlogged and bloated, which leads to apathy and eventual death from boredom. Between the frequent cannibalization and teeth flossing mishaps, their population is kept well under control.

Mating occurs once a year on the male's birthday. The female lays a large batch of eggs, which the male fertilizes. If this is not done to the female's satisfaction, she will eat the male. She would probably eat him anyway, unless, of course, he ate her first. But then he would probably eat himself anyway. In any event, it's a good thing Amphibinasti lay a lot of eggs.

.S TERRAPIN

Remains of the first boat destroyed and eaten by the Island Terrapin, ironically named THE S.S TERRAPIN.

Toxic waste containers were found at the bottom of the Río de la Plata River just downstream from the Island Terrapin.

The large variety of vegetation that grows on the Island Terrapin's shell provides it with effective camouflage.

THE ISLAND TERRAPIN

TOXIC WASTE BELIEVED TO BE BEHIND POPULAR TOURIST DRAW.

The Island Terrapin is not a unique species of sea turtle, but rather a singular freak of nature. This enormous creature is 40 feet in length, and although it has never been weighed, most believe it probably weighs a lot. It consistently roams the waters and inlets of the Río de la Plata River in Uruguay, and has been a dangerous threat to swimmers, fishermen, and recreational boaters for years.

How did this creature grow to such an enormous size? One legend suggests it grew by progressively eating larger and larger boats. Another school of thought is that aliens deposited the enormous turtle on earth to confuse and disorient humans in order to pave the way for an extraterrestrial invasion. Actually, only three people believe that, and two of them are starting to waver. A third explanation is that the Island Terrapin mutated from exposure to toxic waste that was dumped into the waters of the river by a nearby South American mutant research society—this reasoning seems a bit far-fetched, though.

Whatever its origins, this remarkable creature is a great tourist draw and source of great financial gains by the coastal communities—which explains why the Island Terrapin is allowed to live freely despite the continuing rise of deaths it causes each year. As one unnamed local law enforcement official was quoted as saying, "If we killed that animal for killing people, we would be no better than it is. Besides, we would be stuck with a bunch of turtle souvenirs we couldn't sell. People have to die sometime. Does it really matter if it's from old age or being eaten by a giant turtle?"

The Tree Frog, a close relative of the Sloth Toad, apparently provides financial support to its lazy relative.

The Sloth Toad's favorite snack food.

A typical Sloth Toad couch and entertainment center.

SLOTH TOADS

A DEADLY SIN IS MOTIVATING FACTOR BEHIND LAZY TOAD'S BEHAVIOR.

Poor eating habits and a lack of adequate daily exercise are a problem not only in the lives of many people, but also in a certain species of toad. The Sloth Toad gets its name for an obvious reason: It is lazy and overweight. According to scientific research, no Sloth Toad has ever held a job, nor even wanted to. They'd rather spend their days eating and sleeping, with a few hours squeezed in for television. Because of their extra long and powerful tongues, they are able to catch insects without ever moving from their resting spots. Even the threat of a potential predator is not enough to move a Sloth Toad, which has led scientists to believe that the toads would rather be eaten than exert the necessary energy to escape. In fact, one notorious study, in which researchers observed a Sloth Toad in its natural environment, proved this fact. Instead of defending itself when a snake slyly approached it, the toad simply croaked, "I hope you choke on me," as it was being swallowed.

The city of San Carlos, Venezuela, hosts the world's largest population of Sloth Toads. The city dwellers have openly embraced their amphibious residents and do their best to protect them from predatory snakes and birds. As one local proprietor stated, "The amount of bolívares these toads spend on miniature TVs and couches every year keeps this city's economy hopping, so to speak."

Where do Sloth Toads, who refuse to work, get the money to buy TVs and couches? Scientists speculate the money comes from relatives abroad, most likely the much harder-working and altruistic Tree Frogs.

ICE DRAGONS

ICED COFFEE AFICIONADOS BEWARE: YOU'RE NOT DRINKING WHAT YOU THINK YOU ARE!

When people think about South America, what usually comes to their minds are beautiful beaches and lush tropical jungles. However, it is the desolate, snow-packed Andes Mountains that provide a haven for the region's most notable and unique animal: the legendary Ice Dragon.

These fur-covered reptiles break traditional scientific thinking by flourishing in a frigid climate that even the most courageous, warm-blooded creature would fear. How, then, do these cold-blooded creatures survive? According to the 1937 journal of explorer Juan Juanderer, the Ice Dragons are uniquely equipped with a large extra bladder that acts like a hot water bottle to regulate the dragon's body temperature.

It was later discovered that Ice Dragons make frequent trips to the closest towns and villages, where they acquire large quantities of piping hot coffee. They use the coffee to fill their temperature bladders. When the coffee begins to chill, they empty their bladders and make what many people believe to be the best iced coffee in the world—fortunately, these people have no idea where the delicious coffee has been. The dragons trade their iced coffee for more hot coffee, and so the cycle continues.

Many basic characteristics remain cloudy, and several questions still puzzle scientists: Why do the Ice Dragons choose coffee as their heat source? What did they use before coffee was available? Did their bladders evolve out of necessity after the great dragon's migration during the last ice age? Have Ice Dragons always been equipped for the cold weather? Juan Juanderer is, to date, the only person to have researched the dragons, and his surviving journal is vague on factual information. It does mention, however, that a little Irish cream makes the iced coffee "really yummy."

The Ice Dragon uses its ramlike horns as weapons in battles with other male dragons for herd supremacy. They are also used for breaking down and digging out rocks for nest building.

Explorer Juan Juanderer.

The Ice Dragons' extra heat bladder processes iced coffee.

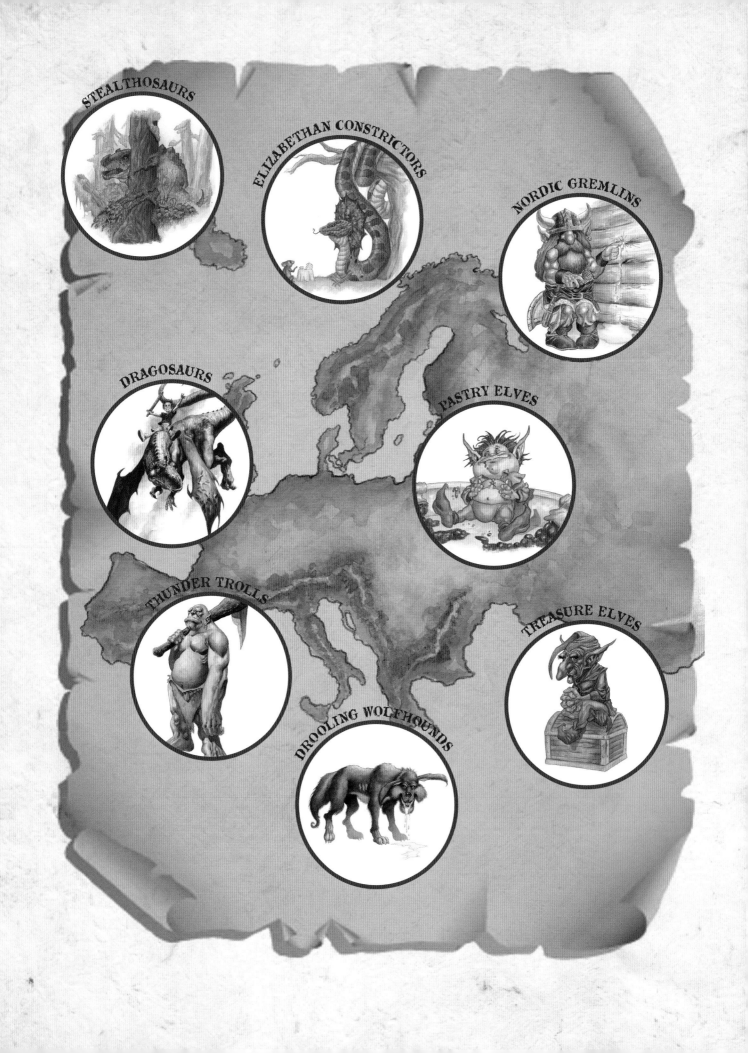

3

CHAPTER

EUROPE

Ham Fabricatini's personal journal entry 3/15/1999

I was attacked by a werewolf the last time I was in Europe. Although I couldn't prove it, I know something hairy almost bit me. I will have ample opportunity to get bitten on this trip as I search for the Drooling Wolfhound and other sharp-toothed creatures. To think this continent harbors dinosaurs, gremlins, dragons, elves, and trolls—a true buffet of the fantastic!

A typical afternoon tea invitation the Elizabethan Constrictor sends to its rodent prey.

The potent sugar cube the Constrictor puts in the rodent's tea to send it into sugar shock.

The Elizabethan Constrictor often wears costume jewelry to maintain its façade of royalty.

ELIZABETHAN CONSTRICTORS

CLASSICS SCHOLARS ECSTATIC TO HEAR PROPER ELIZABETHAN ETIQUETTE IS STILL ALIVE AND PRACTICED IN THE ANIMAL KINGDOM.

The Elizabethan Constrictor is the most regal and proper member of the snake kingdom, and possibly the most sly. Adorned with a fanlike collar and equipped with two tiny but useful arms, it creates an aura of faux royalty that many in the animal kingdom accept as true.

The Elizabethan Constrictor's favorite food is mice and rats, and it uses its regal appearance and manufactured reputation to lure its prey. Since rodents are notorious for being easily impressed and desperate to learn the proper etiquette in order to improve their social standing, it's easy to see how the vicious predator-versus-prey relationship between the Elizabethan Constrictors and rodents continues to this day.

Typically, the constrictor will invite a rat or mouse over for afternoon tea and biscuits, promoting itself as a benevolent benefactor ready to aid the rodent in its quest for an upper-class position. The rat or mouse is usually so desperate to move up the social ladder that it blatantly ignores its natural instinct concerning the dangers of dining with a predator. The snake uses its elegant hands to pour the tea and offer potent sugar cubes. Once the rodent falls into a sugar coma, the Elizabethan Constrictor instantly has an easy meal.

Despite these frequent tea parties, the Elizabethan Constrictor's reputation never seems to get soiled, and the rodents never seem to catch on to the constrictor's ruse. Sadly, as long as the Elizabethan Constrictor is able to project an air of elegance and superiority, there will be rodents willing to be eaten over tea.

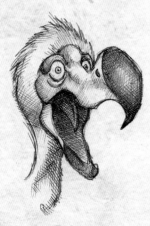

One of the fake beards found at the base of Mount Ararat, circa 1928, worn by the Stealthosaur couple that infiltrated Noah's Ark.

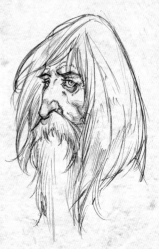

An artist's rendition of a shocked Do-Do Bird just before it was eaten.

An artistic interpretation of Noah, after a hard day of cleaning up after the animals.

STEALTHOSAURS

PROMINENT AUTHOR SHEDS LIGHT ON THE CONTROVERSIAL THEORY OF WHY NOT ALL DINOSAURS BECAME EXTINCT.

What happened to the dinosaurs? According to most scientific theories, dinosaurs became extinct (except for the ones featured in this book, of course) millions of years ago. Another prominent theory, however, proposes that Noah's flood, over 4,500 years ago, wiped out most, but not all, of the dinosaur population. This school of thought is supported by the existence of the last remaining, and the most clever, of terrestrial dinosaurs, the Stealthosaur.

Stealthosaurs still survive today because of their uncanny ability to blend into their surroundings. According to the book *How They Fooled Noah: The Survival of the Stealthosaurs* by I. M. Aliar, a pair of Stealthosaurs snuck onto Noah's ark (which was no small task, considering Stealthosaurs measure about 25 feet from head to tail). Their sneaky disguise was achieved by using fake beards and wigs fashioned from mops, which enabled them to pass as Noah's distant cousins Ike and Florence. Interestingly, because of the Stealthosaurs' predatory nature, they nearly blew their cover when they ate the two Do-Do Birds on the ship. Luckily, most of the other animals hated the obnoxious birds and turned a blind eye. By the time Noah got around to taking the animal inventory, the Ark had settled on Mount Ararat, and the Stealthosaurs, disguised as a couple of doves, snuck off the ship.

Today, Stealthosaurs are rarely spotted (for obvious reasons) but seem to make their home in the densely wooded areas outside of Moscow, Russia. There have been some reports of Stealthosaurs appearing in Red Square disguised as Leonid Brezhnev. This makes sense since Stealthosaurs live in the woods and would have no reasonable way of knowing that Brezhnev was actually dead.

NORDIC GREMLINS

IN-FLIGHT MEAL PLANS PRIMARY REASON FOR NORDIC GREMLINS' MIGRATION.

Although most people think of gremlins as the little creatures that sabotaged fighter planes during World War II, many are unaware that the ancestors of those aerial saboteurs are the Nordic Gremlins. These little critters first worked their mischief on the Vikings hundreds of years ago, giving them both a good and bad reputation among Nordic sailors.

As the legend goes, an infamous Viking named Sven, "The Less Than Mighty," experienced recurring problems concerning tiny holes which would mysteriously appear in the hold of his ship. The holes were immediately attributed to the Nordic Gremlins, although no one had ever actually seen one. Even though the holes were not large enough to sink the ship, they were a constant nuisance to the sailors, as water would slowly seep onto the floors of the ship and create a work hazard. This, in turn, made it nearly impossible for Sven to acquire workman's comp insurance. Needless to say, Sven had a difficult time persuading a Viking crew to sign on to his ship.

One night, as Sven was searching below deck for food supplies to satisfy his late-night hunger pangs, he had a close encounter with a Nordic Gremlin. The little troublemaker was attempting to ream one of the holes with his finger as Sven approached. The gremlin, caught in the act of sabotage, quickly explained that he was only trying to plug the hole in the ship so Sven could get his insurance. The hungry Sven was so moved by the gremlin's apparent thoughtfulness that he ate the creature right there on the spot, declaring the Nordic Gremlin a good meal. Listening to Sven's tale, sailors began to believe that maybe not all gremlins were bad—if nothing else, at least not bad to eat.

Word of this Nordic Gremlin's fate quickly spread to other gremlins, which sent the gremlins fleeing the seafaring vessels for fear of being eaten. They quickly moved from ships to planes, figuring they would be safer because of in-flight meal plans—of course, they had to wait several hundred years until the aircraft was actually invented. In the interim, it is believed they sold insurance to get by.

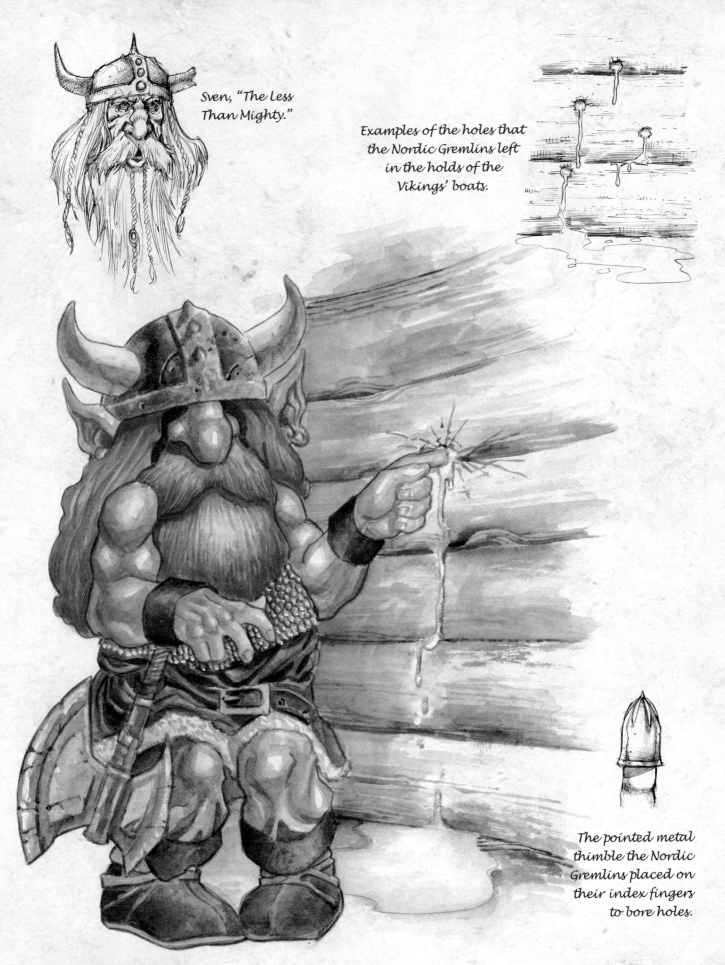

Sven, "The Less Than Mighty."

Examples of the holes that the Nordic Gremlins left in the holds of the Vikings' boats.

The pointed metal thimble the Nordic Gremlins placed on their index fingers to bore holes.

A happy mother of twelve children, who is obviously satisfied with the babysitting service provided by a Dragosaur.

The hands of the Dragosaur, although small, are much larger and more useful than a T. Rex's. They are the perfect size for changing diapers.

Dragosaurs use mud and debris to build a cave hut away from a cliff, rather than using existing natural caves for shelter.

DRAGOSAURS

DUE TO ECONOMICS AND SOCIETAL CHANGES, NEED FOR GENTLE DRAGOSAUR BABYSITTERS DWINDLES.

Dragosaurs, which resemble a T. Rex with wings, first came to prominence during the Middle Ages. While the majority of dragons during that period were breathing fire and engaging in hostilities with glory-seeking knights, the Dragosaurs were busy displaying their kinder and gentler dispositions . . . sort of.

Although meat eaters, the Dragosaurs showed a loving protectiveness toward human children (a trait they still show today). However, the creatures had no qualms about eating an adult or two. It was common practice for a human parent to enlist a Dragosaur for babysitting duties, offering up their spouse or a deadbeat relative as dinner for payment. The practice was very common, since it was really tough to find a good babysitter. During the Dark Ages, sacrificing a problematic spouse was a more than equitable trade to get a few hours away from whiny offspring.

Over the years, the number of Dragosaurs dwindled as homes became two-income households—it no longer made good economic sense to sacrifice a breadwinning spouse in exchange for daycare. Therefore, more and more human babysitters became employed, thus ending the practical need for Dragosaurs. With their diet of humans cut off, the Dragosaurs began feeding on cattle and sheep, which raised the ire of the livestock owners. Not being natural fire-breathers, the Dragosaurs did not have adequate defenses to stave off the frequent attacks by armed livestock owners.

Today, Dragosaurs can be found occasionally working the state fair circuit and making guest appearances at circuses. Their unique physical appearance is always popular with the kids. Dragosaurs still represent a real threat to adults, but at least the parents now know enough to scatter during lunchtime.

The elves' sugary diet, combined with a horrible dental plan, leaves many Pastry Elves with missing or rotted teeth.

The telltale sign that a Pastry Elf has vacated the premises are small, powdered-sugar footprints near a door or window.

Pastry Elves never wear belts. Instead, they prefer stretch-waist pants, which allow for tummy growth.

PASTRY ELVES

SUCCUMBING TO GREATEST WEAKNESS,
GANG OF SWEETS-OBSESSED PASTRY ELVES STRIKES AGAIN.
LOCAL PARISIAN PROPRIETORS OUTRAGED.

"Who ate the last cookie?" and "Who ate the last piece of pie?" are common questions in every household. The answer is not Dad, or the annoying second cousin, or even the bothersome little brother; it is the little-known and rarely seen Pastry Elves. The name of these little creatures is a bit misleading in that they not only eat pastries but any sugar-laden baked dessert—except, of course, rice pudding. Who in their right mind would put rice in pudding?

Pastry Elves are extremely clever and very patient. To avoid detection, they will always wait to eat the last remaining portion of a dessert. Disappointed kids soon start accusing their siblings or parents, since they seem the most logical culprits. Studies show that over 25 percent of all family squabbles are dessert related, and the majority of those are caused by Pastry Elves and their mischievous dessert snatching.

Although the Pastry Elves can be found worldwide, they most often appear in France because of their insatiable cravings for Parisian pâtisseries. They are most active during the holidays, and are most commonly found at Grandma's house. They obviously know when, and where, to strike. The only surefire way to prevent one (or more) from eating the last piece of dessert is to never leave one. Experience has shown that eating the last two pieces at the same time will frustrate and confuse the elves. Over time, this strategic behavior will drive them out of the house and on to greener pastures, or sweeter pastries. However, be warned: Never assume they have completely vacated your home until you see the telltale sign of powdered-sugar footprints by the doors and windowsills.

An invisible Treasure Elf sitting on his chest in a dirt clearing.

Treasure Elves will often use a pillow to improve their comfort level while sitting on their treasure chests.

A typical Elf Revenue Service agent.

TREASURE ELVES

AGENTS NAB MYSTERIOUS CREATURES IN TAX-EVASION SCHEME.

Just like the fictional leprechaun, the Treasure Elf is responsible for guarding large collections of riches. However, unlike leprechauns, being responsible for one treasure chest is this elf's only job. The treasure is used for elf and fairy disability and retirement policies, so its importance to the elfin community is immeasurable.

The Treasure Elves are equipped with the power of invisibility, which means as long as they are sitting on the treasure, both they and the chest remain undetectable to human eyes. If an elf were to leave the chest, it would become visible, thus becoming liable to thievery (horseplay and tomfoolery are always possibilities as well).

All of this adds up to a painfully—especially in the rear—boring and tedious existence for the poor elves: no social life, no friendly outings, and, most bothersome of all, no cable TV. They sometimes receive the occasional letter from home, but since they spend a majority of their time invisible, it is nearly impossible for the mail service to find them. It should be noted that since 1978, postal gremlins have been in charge of mystical mail service, but they have never liked the elves. So it is entirely possible that the gremlins aren't even trying to deliver their mail.

Even though Treasure Elves are magical beings, they do have one mortal predator, the always-ravenous Drooling Wolfhound (see page 68). The Wolfhound has the ability to see through the Treasure Elves' cloak of invisibility, leaving them nearly defenseless during face-to-face confrontations. To counter this, the Treasure Elves try to place their treasure chests on high-altitude, open ground in hopes of enticing a lightning strike on their quarry.

The only time a Treasure Elf is free from guard duty is if the elf is eaten, or the ERS (Elf Revenue Service) takes the treasure for disbursement. Since elves are immortal, it is not clear when exactly they would retire or need the money. It is also confusing as to what exactly they are retiring from. But once a Treasure Elf is relieved, he or she is forced to acquire a new vocation. Since they have limited social skills and education, they usually end up in government jobs or telemarketing.

DROOLING WOLFHOUNDS

FATAL THUNDERSTORM TAKES THREE WOLFHOUNDS.

Although not creatures of magic, Drooling Wolfhounds are the one true predator of elves. The Wolfhounds' hyperkeen senses allow them to easily track and kill magical elves. They never kill for sport, only for food. However, the problem is that Drooling Wolfhounds always seem to be hungry. Their insatiable hunger keeps a steady flow of saliva pouring from their mouths, thus giving the Wolfhounds their name—which, coincidentally, gives the hounds endless grief. Although expert killers, these creatures find themselves slipping on their own trails of drool more often than not—a handicap that seems to even out the odds between predator and prey. If the Wolfhounds were able to hunt unabated, they would more than likely wipe out the entire population of elves in no time.

A Drooling Wolfhound will also eat other small animals when an elf can't be located quickly enough to satisfy its pangs of hunger. Wolfhounds used to prey on gnomes as well, but gave up due to their growing scarcity. The gnomes, who are obsessive tournament bowlers, have all but vacated the woodland areas to go on tour. With the gnomes away bowling, Drooling Wolfhounds quickly limited their menu to the tasty elves. (I have never actually tasted an elf, but have heard they are quite good.)

The population of Drooling Wolfhounds is held in check, not by other predators, but oddly enough by lightning bolts. The Wolfhound oftentimes finds itself on high-altitude peaks (see Treasure Elves on page 67) when hunting, which makes it a likely lightning target during thunderstorms. A large animal that is standing in water (in the hound's case, saliva) on a high peak during a thunderstorm—well, you do the math. There's a safety lesson in there somewhere.

*One of many high, open peaks that the
Drooling Wolfhound travels in search of food.*

*The Drooling Wolfhound
has small, beady eyes that
accurately give away its sin-
ister nature, at least as far
as its prey is concerned.*

*A torn elf boot in a stream of drool
is an all-too familiar sight in the
Wolfhound's hunting grounds.*

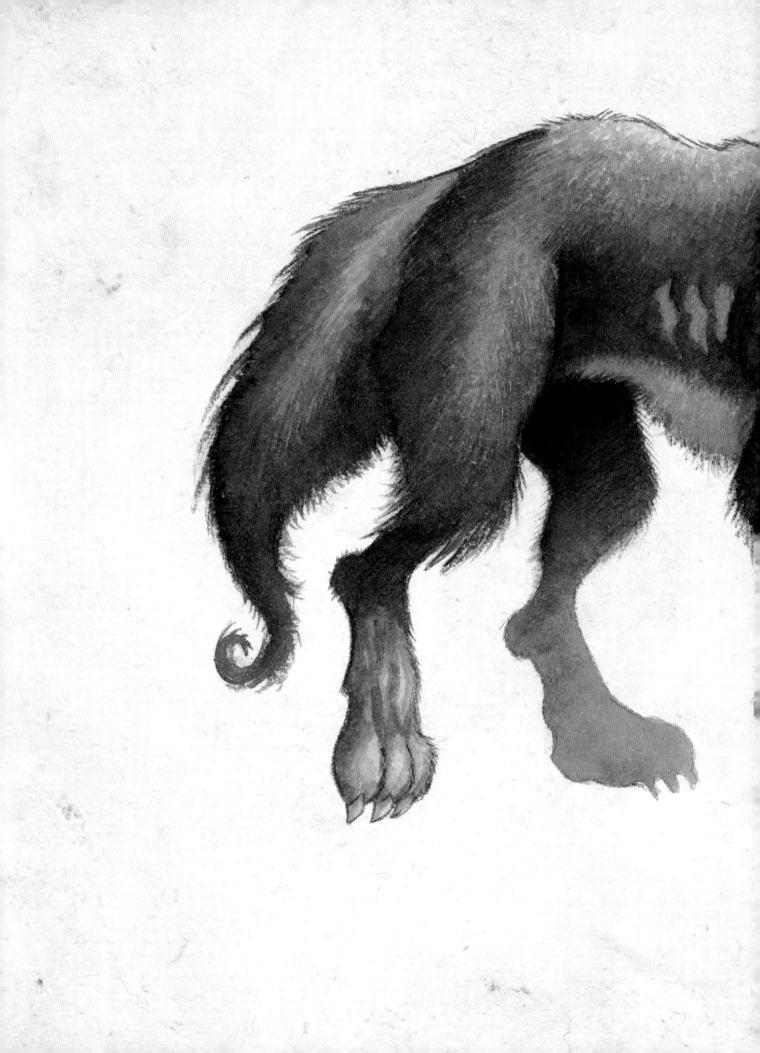

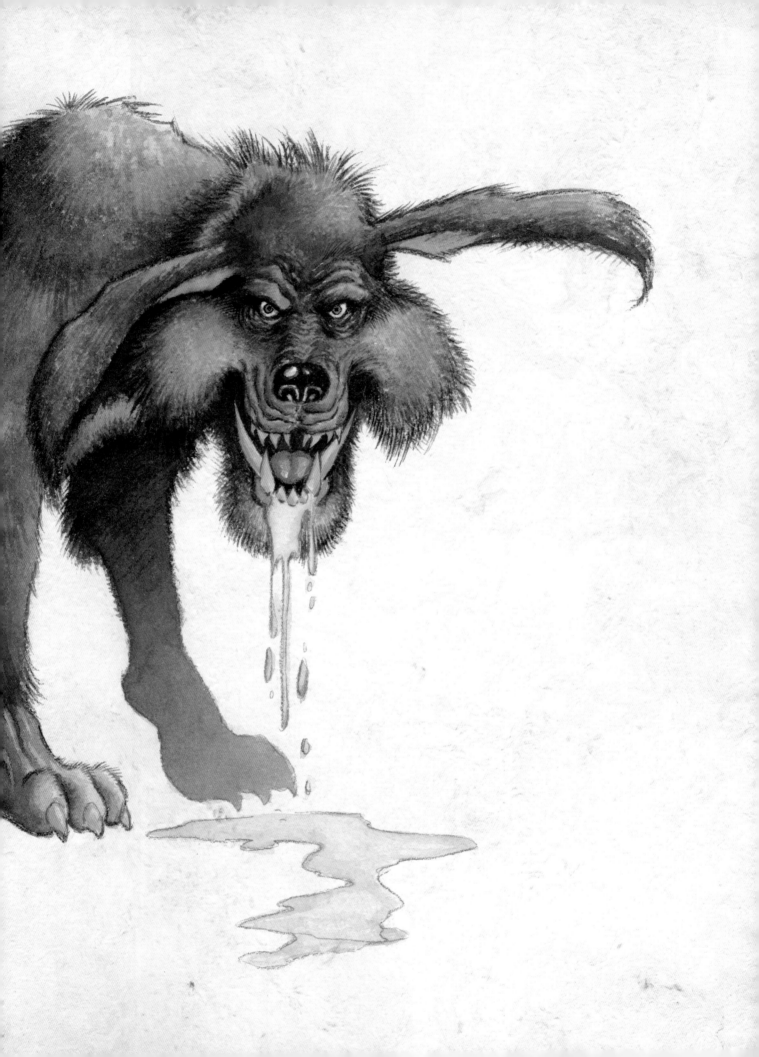

The first official forged-
metal coffee mug used at
the original Troll's Butte
coffeehouse.

After their first
successful building
project, male Thunder
Trolls receive a simple
hoop earring made
of a metal unearthed
from the building's site.

The wrists, hands, and
fingers of Thunder Trolls
are very thick and powerful,
which enable them to
effectively perform their
hard manual labor.

THUNDER TROLLS

WHAT'S IN A NAME? RESEARCHERS TRACE SMALL MISUNDERSTANDING TO MEDIEVAL TIMES.

Thunder Trolls are a race of large (8 to 10 feet in height) trolls that flourished in the Twelve Pins Mountains of Connemara, Ireland, during the Middle Ages—and the small mountains continue to house the trolls' biggest settlement to this day. Their name originated from the towns' nobility. At night, continuous, loud, thundering sounds would emanate from the mountains on a routine basis. Rumors quickly spread that the sound came from the trolls' mining for precious jewels. Of course, when the nobility caught wind of the potential wealth that could be had, they quickly befriended their mighty neighbors.

As the story goes, the noblemen of Ireland entertained various troll leaders at parties and festivals, hoping to gain access to the untold riches they believed the trolls were hoarding deep inside the mountains. Even though the trolls knew of the noblemen's ulterior motives, they found it difficult to pass up the free hors d'oeuvres the nobles offered.

As it later turned out, the trolls were just prolific builders and aspiring entrepreneurs. The thunderous sounds the noblemen heard were the Thunder Trolls building what turned out to be the first Irish coffeehouse. Built into the side of the mountain cliff, this precursor to the modern java joint was originally named Troll's Butte.

Unfortunately, the trolls' business venture was a financial disaster. Their lack of patronage was at first attributed to the franchise name. Apparently a widespread mispronunciation of the coffee house's name turned the stomachs of many would-be customers. After all, who wants to drink coffee from a troll's. . . well, you get the idea. The name was quickly changed to Trollbucks, but it, too, failed to create the necessary cash flow to keep the shop open. It was later decided that the remote location, which could be reached only by pack mule and an elaborate system of pulleys and climbing cables, was the real reason behind the lack of patronage.

The Thunder Trolls soon gave up their coffee dreams and became excellent castle builders for the noblemen. Although they insisted on ten-minute coffee breaks every two hours, the generous trolls always brought enough java for everyone.

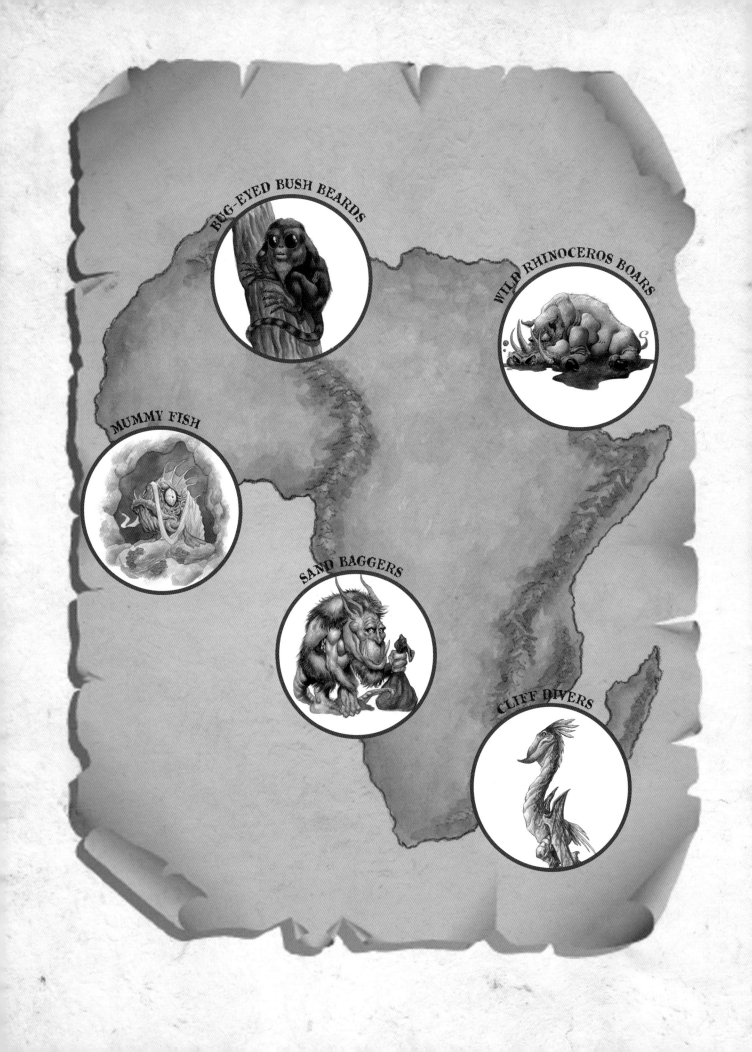

BUG-EYED BUSH BEARDS

WILD RHINOCEROS BOARS

MUMMY FISH

SAND BAGGERS

CLIFF DIVERS

4

CHAPTER

AFRICA

Ham Fabricatini's personal journal entry 1/7/2000

It is hot here, and there are more mosquitoes. Thankfully, I haven't contracted any more diseases so far . . . well, at least that I know of. I have, however, uncovered the Sand Bagger and the Bug-eyed Bush Beard. I know this continent harbors more fantastical creatures, and I am dedicated to finding them. I have heard park rangers tell of a strange wild pig, a feathered reptile, and even some whispers of an undead fish—I can't imagine it would make for very good eating.

BUG-EYED BUSH BEARDS

SCIENTISTS CONFIRM SOCIETAL PRESSURE AND AGE DISCRIMINATION ARE ALSO PRESENT IN THE ANIMAL KINGDOM.

Scientists have recently confirmed the controversial theory that Bug-eyed Bush Beards are indeed the elderly social castoffs of the African Bush Baby. It appears that Bush Beards formed their own subspecies approximately two hundred years ago. Male Bug-eyed Bush Beards are easy to identify because of their long, gray beards. It is believed that at one time females also wore majestic gray beards, but scientists think that due to male pressure and for aesthetic reasons, females began to wax their beards.

Although now separate species, the Bug-eyed Bush Beards and the African Bush Babies still maintain certain similarities. One notable difference, however, is the Bush Beard's large eyes, which provide excellent night vision for their nocturnal lifestyles. Many believe that the Bush Beard's eyes have evolved to be larger due to years of poor vision plans and the rising costs of corrective eyewear.

Ironically, Bug-eyed Bush Beards have proven to be more prolific than their African Bush Baby cousins, who originally ostracized them because of their age. Scientists attribute their rabbitlike reproductive habits to the fact that there is little else to do after their Saturday night African Bush Bingo. Male Bug-eyed Bush Beards are also often seen flirting with the females after their weekly all-you-can-eat buffets.

Scientists still cannot figure out why the Bush Beards do not pair up before the buffet, since it offers two meals for the price of one. Apparently, love does not have a price tag.

The Bug-eyed Bush Beards' claws are long and sharp on both their hands and feet, which aids them in climbing and digging for insects.

A Bush Beard with one ear pricked up to listen for prey.

The Bug-eyed Bush Beard's long and agile tail helps it to climb and swing from trees.

A recovered party favor from one of the infamous animal jungle parties. Notice the telltale bite marks and palm tree motif.

To protect its eyes from the scorching sunlight and mud-hole debris, the Wild Rhinoceros Boar has a very thick brow and eyelids.

The boar's nostrils are covered with hair to keep insects and mud from entering the nasal cavity.

WILD RHINOCEROS BOARS

SCIENTISTS CONFOUNDED TO FIND
LAUGHTER IS BOAR'S BEST DEFENSE MECHANISM.

What do you get when you cross a rhinoceros with a pig? A Rhinog! A bad joke, yes, but a true statement nonetheless. The Rhinog, or Wild Rhinoceros Boar—as it is more commonly known—lives mainly in central Africa, although a few have been spotted in Australia (it is now believed that those few were just vacationing). The Wild Rhinoceros Boar is mainly a vegetarian, but because of its innate laziness and lack of interest in foraging, it will pretty much eat anything that crosses its path—as long as too much chewing is not required.

Physically, what sets the Wild Rhinoceros Boar apart from other wild boars is its relatively hair-free body and leathery, rhinoceros-like hide. Similar to the endangered Sumatran Rhino, the Wild Rhinoceros Boar also has two horns on its snout. From what researchers can tell, the horns are used primarily for poking other Wild Rhinoceros Boars in the rear to get laughs, which makes them welcome guests at any jungle party. The boars may eat a lot at the parties, but they provide hours of sophomoric entertainment.

The Wild Rhinoceros Boar is also equipped with two tusks jutting out from its jaw. The tusks are used mostly for digging, but also as defensive weapons—although fighting requires more thought and energy than the Wild Rhinoceros Boar seems capable of producing.

The Wild Rhinoceros Boar is now officially classified as an endangered species. They are not hunted by man, but instead tend to be their own worst enemies. Because they are so lazy, they often refuse to migrate during the dry season. This usually leads to fatal battles with crocodiles and other predators around drying mud holes. The Wild Rhinoceros Boar has little chance against large predators unless it can strike first with a "fanny" poke. At that point, laughter erupts and the party begins, which will usually rage on until the water has completely dried up and everything is dead. The upside is that they usually die smiling.

Gore Smeltzer, the marine archeologist that first discovered Mummy Fish.

The lesser-known Egyptian water god, Bubbles Osiris.

MUMMY FISH

MARINE ARCHEOLOGIST DISCOVERS THE PYRAMIDS WEREN'T ONLY FOR THE PHARAOHS.

The pharaohs of ancient Egypt always were entombed with their treasures and prized possessions. Scientists have recently discovered that this practice extended beyond the Egyptian sand, and into the water.

Fifteen years ago, marine archeologist Gore Smeltzer was the first to discover the underwater tombs of the pharaohs. However, more startling than the tombs themselves was what Smeltzer discovered inside: fish swimming the swim of the undead. Some have dubbed them "zombie fish," but their clinical name is Mummy Fish.

According to archeological research, it appears some pharaohs kept fish as pets, and commanded that their gilled companions be mummified and buried in underwater tombs just off the coast of Alexandria once they died. The fish were entombed under the guard of the lesser-known Egyptian god Bubbles Osiris, who was Osiris's half brother twice removed. As legend has it—and which has, remarkably, been proven to be true—once the tomb's seal was broken, the power of Bubbles would come upon the fish, and they would rise from their watery graves.

Smeltzer observed that once a fish has risen, it really doesn't have much to do. Being undead, they don't eat or reproduce; they just sort of swim around like, well, like zombies. Because these mummies are just skin and bones, and any meat they might have left on their bodies is already spoiled, other fish do not eat them. It is difficult to determine their life spans, given that they are already dead. Without natural predators or chance of any life-threatening disease, Smeltzer speculates Mummy Fish simply go on existing until they die from being dead too long.

An ancient Egyptian fish food dispenser recovered from a Mummy Fish's tomb.

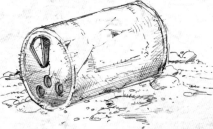

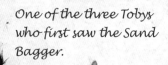

One of the three Tobys who first saw the Sand Bagger.

Sand Baggers will often chase tumbleweeds for recreation and exercise.

A partially eaten sandwich left behind by a Sand Bagger.

SAND BAGGERS

BIKER GANG STUMBLE UPON STRANGE SIGHT IN THE MIDDLE OF DESERTED DESERT.

Where does all of the sand in the desert come from? This baffling question was finally answered in 1972. A gang of American bikers (actually, three guys named Toby) ran out of gas along a lonely stretch of highway in California's Mojave Desert. On the second night of their trek back to Los Angeles, the three men became the first humans on record to see a creature now known as a Sand Bagger.

The following excerpt was taken from the original statement given by one of the Tobys: "I was almost asleep when I spotted this gold-colored goblinlike thing carrying a small burlap sack and eating a sandwich. I thought it was really strange, because it's impossible to eat a sandwich in the desert—or the beach—without getting sand in it. Then you get the sand in your teeth and it just grinds. I hate that!"

Based on the account of the three Tobys, researchers set up outposts in several desert regions around the world and came to a startling revelation: It gets really hot out there during the day. In addition, two outposts recorded sightings of Sand Baggers in action. One detailed report read, "We witnessed the creature emptying a small sack of sand in various spots throughout the desert. The bag seemed to produce a continuous flow of sand without ever having to be refilled. Strangely, the creature was eating a sandwich. . . . " Although most scientific sightings have occurred in African deserts, half-eaten sandwiches have popped up in various deserts around the globe.

How the Sand Baggers generate their sand and why they work in the desert, but not in children's sandboxes, is still under investigation. Reports have started to surface that both faeries and the Sandman buy sand from the Sand Baggers, although the sand has never been conclusively traced back to them.

For the immediate future, scientists are focusing on the origins of the sandwiches. One prominent Sand Bagger researcher believes, "If we can locate the source of the Sand Baggers' sandwiches, we could at least have something decent to eat at these outposts."

The lemming is the Cliff Diver's closest relative.

A Russian diving judge, circa 1974.

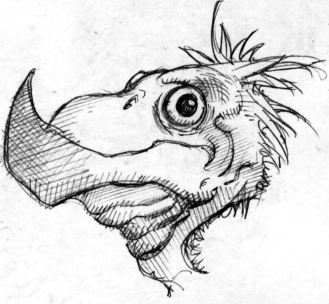

An adolescent Cliff Diver has large eyes in proportion to its head size. As it matures, the eyes stay the same size while the head continues to grow.

CLIFF DIVERS

TOUGH PARENTAL LOVE MEANS SURVIVAL TO THESE BIRDS.

At first glance, Cliff Divers often are mistakenly thought to be close relatives of a prehistoric bird or perhaps even the more modern Metropolitan Pterosaur (see page 17). However, even though Cliff Divers are flying reptiles, their closest relative is the lemming. While both animals have a habit of leaping off cliffs, the Cliff Diver jumps mainly for food while lemmings jump because they are easily confused and make really poor decisions.

The Cliff Diver's superb vision allows it to spot fish from as high up as 100 feet. Its long-range vision, combined with an uncanny ability to execute pinpoint dives, makes the Cliff Diver a top-notch fisherman and Olympic diver—although it never seems to get a fair score from Russian judges.

For convenience and practicality, Cliff Divers make their nests along the cliffs of Cape Point, South Africa. The average Cliff Diver female will lay only two eggs a year. Although the young are passionately cared for by their mothers, it doesn't take too long before the fathers grow impatient and kick their offspring out of the nest. This forces the young to learn to fly and dive very quickly, or suffer the embarrassment of a high-altitude belly flop. Some males will allow their young to stay in the nest longer, provided they are willing to pay rent. Most young Cliff Divers, however, opt to find their own way once they have been booted from the nest, embracing their new independence and opportunity to make their own nests. Even after establishing their own lives, young Cliff Divers will still return to their parents' nest during the holidays, so their mothers can feed them and do their laundry.

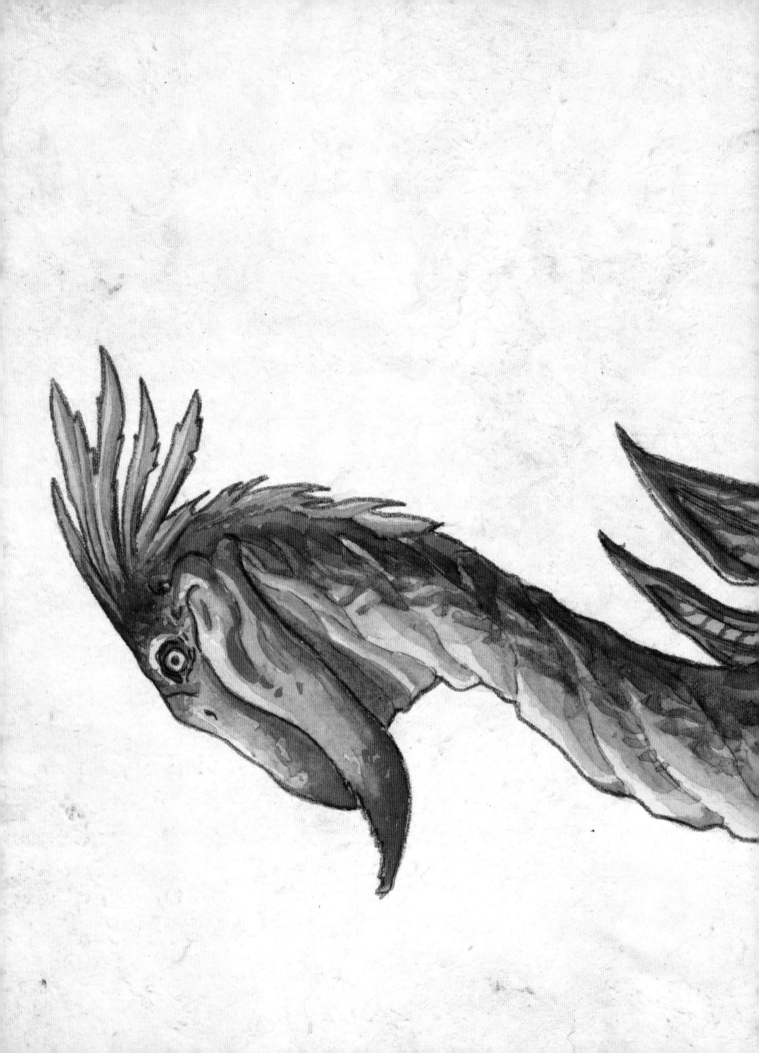

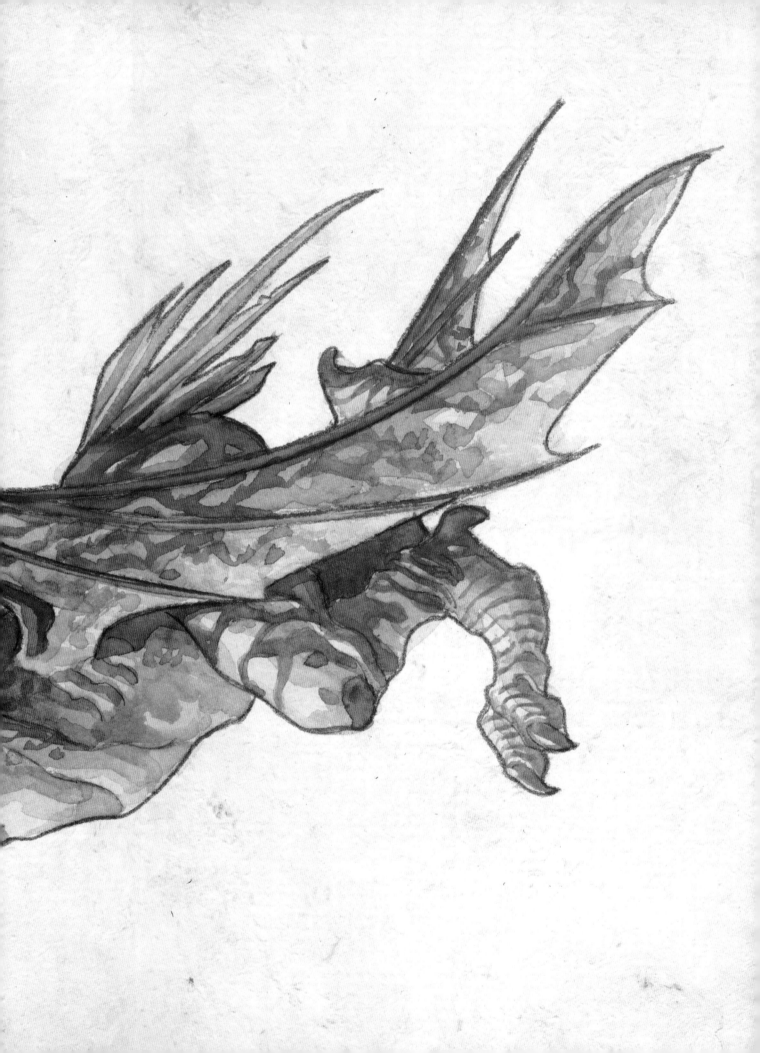

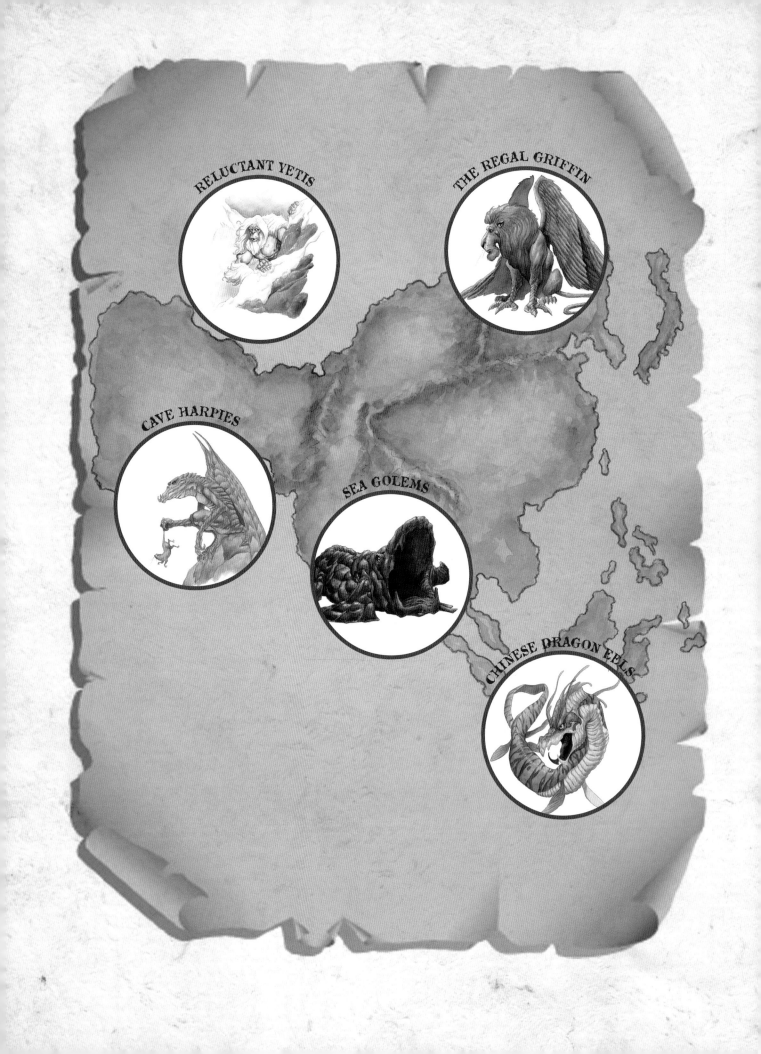

RELUCTANT YETIS

THE REGAL GRIFFIN

CAVE HARPIES

SEA GOLEMS

CHINESE DRAGON EELS

5

CHAPTER

ASIA

Ham Fabricatini's personal journal entry 1/30/2001

Who would have thought finding good Chinese food in Asia would be so hard? I did, however, find an American hamburger joint. I have a feeling it will be like my jaunt through South America, as there are many diverse terrains and climates in these parts. I'm planning to sail on the ocean, explore caves, go rock climbing, and even hike through the Himalayas. All in all, I think it will be a successful trip. I'm hoping to discover the Cave Harpies and the famous Reluctant Yetis.

The eyes of the Cave Harpy are very small and don't provide very good vision, which is probably the result of living in dark caves and coming out only at night. They have an acute sense of radar, much like a bat, to make up for the disadvantage.

Cave Harpies have thick, padlike scaling on their shoulders to give greater protection when scraping against the rocky walls and surfaces of their caves.

The *young* **Pete** Crevace before entering the Gy**okusen**do Caves, where he encountered Cave Harpies.

CAVE HARPIES

HIGH INTEREST RATES AND THE CARTER ADMINISTRATION ARE TO BLAME FOR CREATURE'S RECLUSIVENESS.

American adventurer and spelunker Pete Crevace was the first to discover the Cave Harpy in 1927, while searching for his hair net in the Gyokusendo Caves of Okinawa, Japan. In the darkest recesses of the Great Crevace Crevice (which Pete named after himself), he found a small colony of leathery-winged reptilian harpies. Terrified by their size (8 to 10 feet from the snout to the tip of the tail) and appearance, Pete Crevace panicked and ran blindly into the bowels of the cavern. He became lost and disoriented, and didn't find his way out for fifty years. Unfortunately for him, when he finally made his way back to the United States, it was right in the middle of the Carter administration. The out-of-control interest rates sent him screaming back to the caves of Okinawa, but not before recounting his tale to a used car salesman.

By the early 1980s the story had gained enough steam that a research party was formed. They set out to the Gyokusendo Caves with low expectations, but after only three days of searching did they find the lost hair net along with the clan of Cave Harpies and the eighty-five-year-old Pete Crevace.

Apparently, Crevace had been telling the harpies horror stories about the U.S. economy and its possible ramifications for the Asian markets, making the animals much more reluctant to leave their caves. When they did, it was only to catch food at night. One harpy would go out and catch enough rodents for the whole clan, thus protecting their clandestine home and the integrity of their family.

Today, the Cave Harpies continue to live a similar lifestyle—although they are more apt to leave their caves now that interest rates are lower.

An old Chinese fisherman.

*The jaws of the Chinese Dragon Eel
are perfectly formed for hooking
and holding on to their catch.*

*A Chinese Dragon Eel breaking
the surface of the water,
probably looking to pilfer fish
from a fisherman's boat.*

CHINESE DRAGON EELS

FISHERMEN VS DRAGON EELS:
AN OLD SCORE THAT IS STILL NOT SETTLED.

For centuries, local Chinese fisherman have told tales of a sea monster that lives in the dark depths of their fishing grounds. Western science has finally identified these most unusual creatures as the Chinese Dragon Eels, sometimes referred to as Ralph. The origin of the latter name is more of a mystery than the creature itself.

Plentiful in the waters of the East China and the Yellow Sea, these eels are unique in that they have a serpentine head followed by a typical eel-like body. Though significantly smaller than the beasts of legend, the Chinese Dragon Eel can still grow to a size of 10 feet in length.

According to fossil remains and a really old fisherman, Chinese Dragon Eels have inhabited Chinese waters for centuries. Originally inhabitants of Australia's Great Barrier Reef, Chinese Dragon Eels repeatedly failed to make rent payments and were evicted from the popular reef and vacation destination. As the legend goes, the eels moved to the Chinese waters, lured by the low rent and minimal landlord interference. They found the water to be plentiful with fish and have been battling the local fishermen for fishing and casino rights ever since.

With its colorful markings, the Chinese Dragon Eel can be easily spotted, but its length makes it a challenging obstacle for smaller fishing boats. Besides the threat of collision, Chinese Dragon Eels have been known to sneak up on fishermen's boats and steal their fish. It shouldn't be surprising that a marine animal unwilling to pay rent would have no qualms about stealing fish.

A typical coral magazine rack found
in the stomach of Sea Golems.

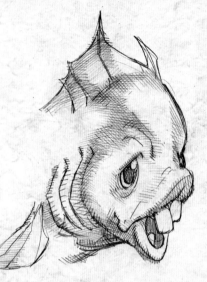

A really stupid fish.

A scale of a dead Sea Golem
shows how the fish mutates into
a solid, siliconlike substance.

SEA GOLEMS

LACK OF JUICY GOSSIP TABLOIDS POSES MAJOR THREAT TO THESE "ROCK" BOTTOM DWELLERS.

When first hatched, Sea Golems swim around like any other fish. However, as they grow, so does their body mass, which results in a Golem becoming so heavy that it can no longer swim or stay afloat. In addition, Sea Golems are born with a special gland that releases a hardening enzyme into their systems as they age. The enzyme turns the Golems' cells into an inert, stonelike material. This process is clinically referred to as "hitting rock bottom."

Once a Sea Golem has completely hit rock bottom, it sinks to the ocean floor, where it settles for life. The entire process leaves the Sea Golem feeling depressed—and weighed down with a negative attitude. This sad state, however, is usually short-lived, and is quickly replaced with a rapturous feeling that things will soon look up. Unfortunately, once the Sea Golem realizes it can't look up (because its head is too heavy), it settles into the acceptance stage and tries to move forward with its existence (not literally, because it is, again, too heavy).

Once the Sea Golem accepts that it has hit rock bottom, it is forced to lay around with its mouth agape, trying to catch food. Its hope is that a really stupid fish will swim by and enter its mouth. Fortunately, a Golem's stomach is naturally equipped with interesting reading material to help encourage a fish to hang out until digestion occurs. The only problem is that it is next to impossible for a Sea Golem to maintain up-to-date reading material, which it desperately needs to lure new prey. As a result, the Sea Golem has a very short life span and usually dies from starvation.

The Sea Golem's somewhat futile existence has led four out of five marine biologists to determine that hitting rock bottom is a state that most should try to avoid by using whatever means available to stay afloat.

THE REGAL GRIFFIN

HISTORIANS FIND REGAL GRIFFIN WAS HARBINGER OF COPYRIGHT INFRINGEMENT.

The majestic Regal Griffin is, in more ways than one, responsible for its own obscurity. This creature has the distinction of being the first being (man or beast) to undertake legal action to protect its likeness. In an ancient world, where lawsuits were relegated to bickering over whose urn was whose, this trendsetting animal bounced the legal community (actually just a couple of guys who could read) on its ear.

The Persians originally discovered the Regal Griffin in the ancient Middle East. Being they were so enamored with the unusual appearance and majesty of the creature, they wanted to preserve its legend in their art. But the Regal Griffin would not allow its image to be used without substantial compensation. At that time, the Persian Empire ruled the world, and as Cyrus the Great said, "No chicken-legged lion is going to dictate terms to us!" So the artists of the time, by order of the king, developed a copyright-free version of the griffin that they could use and propagate.

The Regal Griffin's stubborn refusal to allow himself to be exploited ironically resulted in the creation of the mythological griffin that many of us are familiar with today. While the Regal Griffin has the head of a lion and the claws of an eagle, the Persian creation has the head of an eagle and the body of a lion. Apparently, the courts at the time felt the Persian design was different enough from the Regal Griffin's makeup to not warrant any legal action. As a result, the mythical griffin has gained immense popularity, while the Regal Griffin toils in obscurity.

Sadly, what has been lost in all of this legality is the earnest interest in learning more about the creature. Most researchers are afraid to pry too deeply into the mysteries of this wonderful creature for fear of a lawsuit.

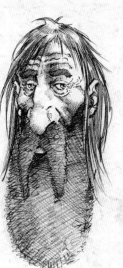

Sirius the Artist, brother of Cyrus the Great, was one of the artists ordered to develop the griffin design (an excellent example of ancient world nepotism).

The Regal Griffin's eagle-like talons are excellent for capturing prey from the air or scratching a really itchy spot.

The Regal Griffin makes its den nest high up in caves on cliff walls. This helps maintain its privacy.

RELUCTANT YETIS

RED OR BLACK LICORICE?
BEWARE: THE CHOICE MAY MEAN OSTRACISM.

The Reluctant Yeti, also known as the Shy Sasquatch or the Un-Abominable Snowman, is a creature that is not at ease with who or what it is. Since the discovery of these creatures some fifty years ago, it has been very difficult to gather correct information on them. Most Reluctant Yetis are, well, reluctant to talk about themselves. When one does speak, it will often deny even being there.

What we do know is that Reluctant Yetis inhabit the Himalayan Mountains and can grow to an intimidating height of 8 feet. They keep in regular touch with their close relative the Snow Giant (second cousins, really) from the Arctic (see page 123). The Snow Giants, being a much more outgoing species, have no problem with providing information on these socially awkward Yetis.

According to the Snow Giants, the Yetis fractured into two separate colonies centuries ago, one which preferred red licorice and the other preferring black. As the worldwide popularity of red licorice grew, the black-licorice-favoring Yetis were completely ostracized. It became an embarrassment for the red-licorice Yetis, and even local villagers, to socialize with them. As the licorice fad died out, the ostracism and ridicule continued. Finally, the red-licorice-favoring Yetis moved to warmer climates, lost their fur coats, and became encyclopedia salesmen. The black-licorice Yetis remained in the Himalayas, but years of oppression took their toll. Lacking self-confidence and self-esteem, they became known as the Reluctant Yetis, refusing to admit their identities or acknowledge their past. It is interesting how choosing one consumer product over another can lead to the formation of a species—in some ways, similar to choosing Beta over VHS.

Although the hands of the Reluctant Yeti are human-looking, they are much larger and have longer fingers, which makes them excellent tools for hiding their faces.

Black licorice was a bad choice. It led to the social demise of the Reluctant Yetis.

A typical Yeti's snow-covered cave dwelling.

NO ONE'S HOME!

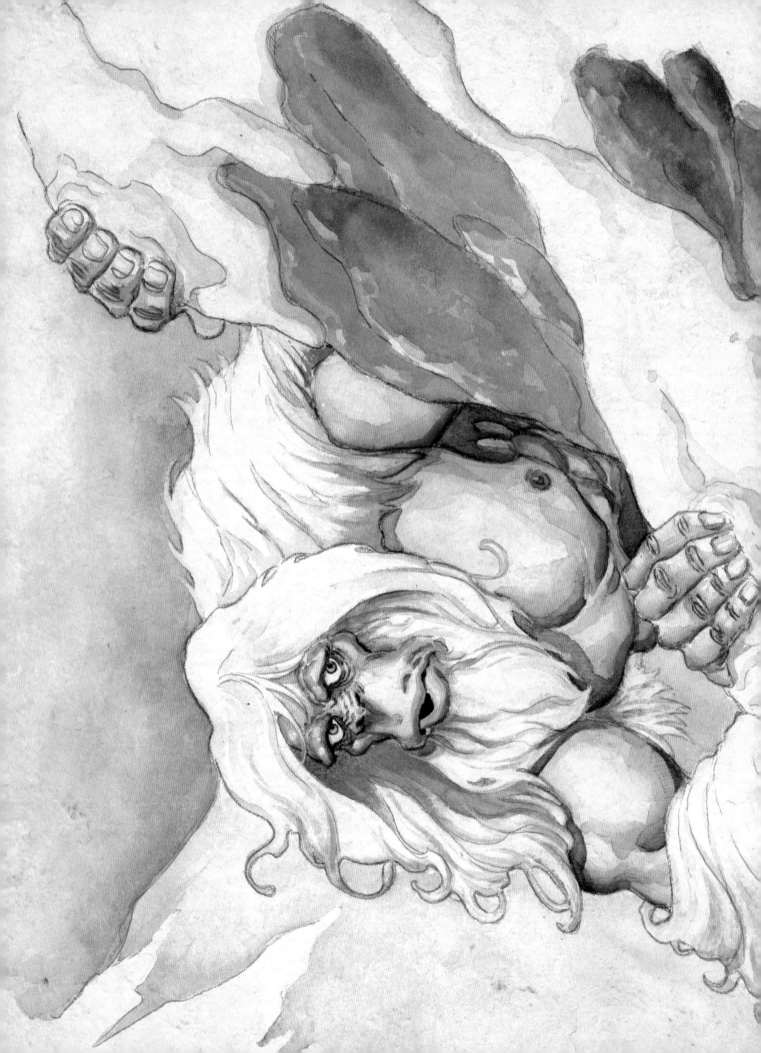

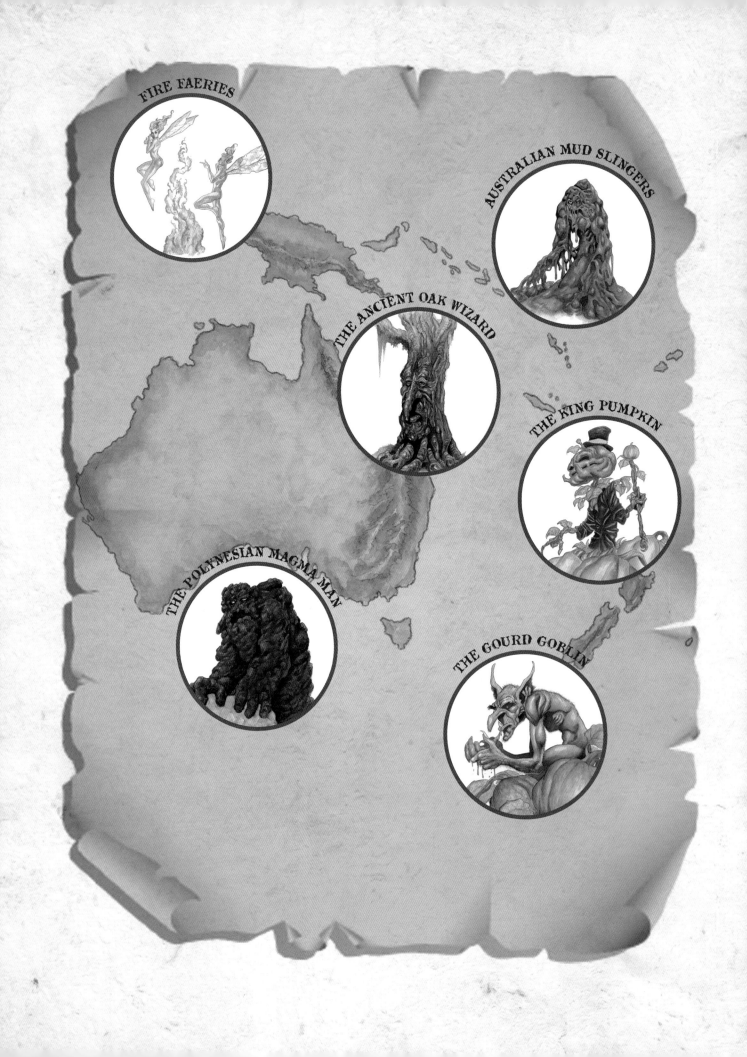

FIRE FAERIES

AUSTRALIAN MUD SLINGERS

THE ANCIENT OAK WIZARD

THE KING PUMPKIN

THE POLYNESIAN MAGMA MAN

THE GOURD GOBLIN

CHAPTER

OCEANIA

Ham Fabricatini's personal journal entry 9/13/2001

I can't believe how many strange but well-known creatures there are in Australia and New Zealand. I'm excited to see if I can discover even more strange beasts that may have escaped scientific detection. I have some leads on several mystical creatures, such as faeries and goblins, as well as some bizarre rudimentary ones, like the Magma Man, who is rumored to be made of lava. Finally, I will get a chance to wear the asbestos underwear that I've been saving for years.

A Fire Faery's home is made of nonflammable clay or mud and is usually hung from a tree. Notice the many ventilation windows that allow heat to escape.

During periods of sleep and relaxation, Fire Faeries burn less extra energy, which, as a result, makes the flames on top of their heads burn much lower.

Fire Faeries desire fruitcakes above all else, and will do almost anything to obtain them.

FIRE FAERIES

CAN FIRE FAERIES BE THE NEW SOURCE OF RENEWABLE, GREEN ENERGY?

Moths are not the only things drawn to a flame. These high-energy faeries have the same fascination, only fire serves as a source of energy replacement for them. The constant flame that burns on top of the Fire Faeries' heads is actually an excess energy release port. As a result of their constant energy burn, they are always seeking fire to replenish their energy supply. They absorb the energy through their backsides, which can sometimes result in a Fire Fairy fanny fry. This faux pas usually befalls younger, less-experienced Fire Faeries, and is always a source of bemusement to the older ones.

Fire Faeries act mainly as energy carriers for their fellow cold-climate elves and faeries, many of which make their homes in mountainous regions of New Zealand. Using their surplus energies, they provide power that lights and heats entire elfin towns and villages. They don't provide the service for free, however. Sometimes they will trade their energy for gift certificates, which are good at most elf and faerie shopping malls, but more often than not they will trade the certificates in exchange for their single, great weakness: fruitcake. Fruitcakes have really become the gold standard for most fire faeries, and they will frequently make enormous personal sacrifices to obtain one.

Other than delivering energy, Fire Faeries usually don't interact with other faeries, since their body temperature is hot to the touch. This makes it difficult for them to develop relationships outside their own species. The fact that they are walking (or, in their case, flying) fire hazards limits their social opportunities.

Although Fire Faeries are forced to socially keep to themselves, their popularity is constantly growing—since they offer an invaluable service to segments of the elf and faerie community in need of a clean-burning, environmentally safe, renewable power source. Perhaps one day they will share their talent with the human population.

A squirrel frightened by the Ancient Oak Wizard's investment advice.

TAKE ONE

11

During the peak years of the Ancient Oak Wizard's popularity, a crude ticket dispenser had to be installed on a nearby tree to keep advice seekers in order.

The young oak during its regrowth cycle.

THE ANCIENT OAK WIZARD

STOCKBROKERS ARE IN A PANIC OVER AN OLD SAGE'S MARKET ADVICE.

The legend of the Ancient Oak Wizard has been around since man started lying, or at least since the advent of nut gathering. What was originally thought to be a tall tale in New South Wales, Australia, became a substantiated fact in 1841. A group of highly educated squirrels (the kind that can talk) were gathering nuts when they came upon an old oak tree. The tree suddenly came to life and started offering advice on the stock market. The squirrels, fearful of blowing their retirement money, dropped their nuts and ran. Word of the incident traveled fast, and soon people from all over the world were coming to seek the advice of the Ancient Oak Wizard. Over time, however, the Ancient Oak Wizard proved to be more adept at horticultural advice than finance and real estate offerings. Nonetheless, financiers, along with farmers and woodsmen, still continued to travel great lengths to seek the Ancient Oak Wizard's sagacious advice.

Then, in 1967, after more than a century of reasonably good advice, the Ancient Oak Wizard took a risk and stepped far outside its area of expertise. It boldly predicted, actually guaranteed, an India victory over Australia in their cricket tests. After Australia won an easy 4–0 victory, a mob of angry gamblers stormed the woods and chopped down the Ancient Oak Wizard.

Nature does have its way, though, and it wasn't long before the Ancient Oak Wizard began to grow again. At first it came back like a spry willow, but after a few more decades of unmolested growth it has become a middle-aged know-it-all. Since nobody likes a know-it-all, the hope is that after a few more decades the Ancient Oak Wizard will return again and offer helpful advice to those in need—hopefully just nowhere near the New South Wales gambling territory.

During long periods of drought, the Dirt Men become Dust Men and blow away. Sometimes the dust will blow several miles before resettling and allowing the Mud Slingers to reform.

BEWARE
MUD SLINGERS
PRESENT

A sign posted by a ranger warning hikers and vacationers about the unfriendly Mud Slingers.

In the absence of sufficient rainwater, the Australian Mud Slingers will become Australian Dirt Men.

AUSTRALIAN MUD SLINGERS

MANY BLAME THE NASTY HABITS OF AUSTRALIA'S EARLY SETTLERS FOR SLINGERS' DIRTY MOUTHS.

Australian Mud Slingers are one of the rudest creatures on God's green earth, or in this case, brown earth. In fact, they rival the Raging Rock Mite (see page 119) in verbal abusiveness. They can be found in just about any mud hole in the outback, and will verbally assault anyone who comes within shouting distance. It is commonly believed that their hostility is a defense mechanism developed in the early years of Australia's colonization by transplanted British criminals. The easily influenced Mud Slingers quickly picked up the bad language and mean-spiritedness of the criminal element and rejected the more civil and respectful ways of the indigenous Aborigines. Because of this, the natives turned their backs on the Mud Slingers, which meant no more outback picnics or didgeridoo jam sessions. Although they brought this alienation upon themselves, the Mud Slingers retaliated by slinging mud at their onetime friends, and have been doing it every since.

As unsavory as they may be, collectively they seem to believe that a bad attitude and salty language are matters of age, if not place. In one of nature's greatest ironies, adult Mud Slingers are often seen punishing their children for having dirty mouths. This, however, may be more a state of being than an actual behavior problem. After all, they are made of mud. But if it is, indeed, punishment for verbal inappropriateness, it's a classic example of the old adage: Do as I say, not as I do.

Most local inhabitants and victimized tourists long for the dry season, when the Mud Slingers will dry up and simply become Australian Dirt Men. In some cases, if the drought is too long, the Dirt Men will turn to Dust Men, and blow away like hot air. They will, however, eventually land someplace and settle. When the rain returns, they will become Mud Slingers again. Their presence in a new location will often cause a mass evacuation of the neighborhood, leaving the Mud Slingers feeling rejected once again. This, in turn, fuels their mud-slinging behavior, and so the great circle of life continues.

The King Pumpkin's hands and arms are composed of intertwined vines.

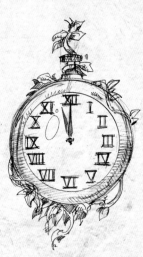

The King Pumpkin always has his trusty pocket watch with him to make sure he appears at 11:59 P.M. sharp every year. Since the witching hour is at midnight, the King Pumpkin likes to make sure he is not competing with other ghouls and goblins during his grand entrance.

Due to his late arrival every year, the King Pumpkin has only undersized and rotting pumpkins as foot soldiers.

THE KING PUMPKIN

NOTORIOUS PUMPKIN TYRANT ARRIVES TO AUSTRALIA,
THIS TIME FOR GOOD.

The King Pumpkin appears only one night a year, October 31st. Halloween night, revered for ghost, goblins, and all things scary, provides the perfect atmosphere for a mystical pumpkin creature with delusions of world domination.

Every Halloween at 11:59 P.M., the King Pumpkin rises from a randomly chosen pumpkin patch with the intention of leading his pumpkin minions in a diabolical plot of world conquest. However, every year, the King Pumpkin faces several recurring problems that prevent him from getting anything accomplished. First, since he waits until nearly midnight to appear, all the really good pumpkins, which he needs as his foot soldiers, have already been picked, bought, or carved, leaving him with little in the way of competent pumpkin help—small or rotten pumpkins make for very poor foot soldiers. The second, and even more damaging, dilemma is the presence of the Gourd Goblin (see page 113), the King Pumpkin's only predator. The mere presence of the Gourd Goblin demands that the King Pumpkin split his time between trying to conquer the world and avoid being eaten.

As if this weren't enough, the King Pumpkin is infamous for creating his own distractions. The biggest is his annual search for an all-night dry cleaner on Halloween, as the King Pumpkin apparently has only one suit, which gets dirtier every year (crawling around on the ground in a pumpkin patch probably doesn't help the situation).

Although the King Pumpkin originally appeared in the United States, more recent sightings have been in Australia. His relocation seems to have coincided with the Land Down Under's relatively new fascination with celebrating Halloween. Perhaps the King Pumpkin sees Australia as a fertile ground to implement his scheme to take over the world, but it is unclear how the King Pumpkin could conquer the world with an army of pumpkins, regardless of his location. In any event, the task becomes even more difficult now that he is stuck on an island—everyone knows pumpkins can't swim.

Pumpkin- or melon-headed humans run a slight risk of being attacked by the Gourd Goblin on Halloween night.

The Gourd Goblin's skin is covered with short, coarse, piglike hairs that protect his naked body from biting insects like mosquitoes.

A typical jack-o'-lantern that the Gourd Goblin would occasionally steal and eat. After repeatedly burning his tongue on the candle inside, he gave up on the practice.

THE GOURD GOBLIN

TWENTY JACK-O'-LANTERNS MYSTERIOUSLY DISAPPEAR—TOWN RESIDENTS ALREADY KNOW THE PERPETRATOR.

Like the King Pumpkin (see page 111), the Gourd Goblin makes an appearance only once a year, on Halloween night. In fact, it seems that the main reason for his appearance is to keep the King Pumpkin in check, although he also provides the useful service of eating leftover and rotting pumpkins lying around pumpkin patches on Halloween. Without the Gourd Goblin's insatiable appetite for pumpkin, and occasionally spaghetti squash, the King Pumpkin would have far greater legions of pumpkin minions to use in his schemes of world conquest.

Even though the Gourd Goblin has had ample opportunities to devour the King Pumpkin over the years, the goblin becomes easily distracted by the common, less agile, vine pumpkins, which are much easier to catch and provide just as much eating pleasure. Despite his inability thus far to catch the King Pumpkin, the constant threat posed by the Gourd Goblin keeps the King Pumpkin from establishing a solid base of operation. Although the Gourd Goblin has a frightening appearance, he poses little threat to trick-or-treating humans. He has been known, on occasion, to steal jack-o'-lanterns from residential porches, but frequent tongue burnings have seemingly put a halt to this behavior. However, he once attacked a man with an extremely large gourd-shaped head, but it later turned out to be a simple case of mistaken identity. All and all, though, the Gourd Goblin provides a great service to mankind and should be considered a friend, unless, of course, you have a really large head.

THE POLYNESIAN MAGMA MAN

NOT THE WINDS OF TIME, BUT MARSHMALLOWS, MAKE LAVETTA STONE IMPOSSIBLE TO DECIPHER.

The island of Tanna in Fiji is the natural home of the Polynesian Magma Man. However, the creature has been sighted on the big island of Hawaii during Christmas and is rumored to have a summer home somewhere near Mount St. Helens, Washington. The common factor in all of these locations is, of course, the presence of active volcanoes. The Polynesian Magma Man is not a man at all, but rather a creature made of living volcanic matter. It uses the subterranean lavaways to travel from one volcano to another, anywhere in the world.

Many researchers believe the Magma Man to be Earth's contractor, the creature in charge of creating, or extending, existing islands, building land bridges, and wiping out existing towns and villages in lieu of newer, more natural real estate.

The major hurdle in communicating with this creature is finding someone who speaks Lavaese. Once a thriving language at the dawn of time, when volcanic activity was at its peak, Lavaese disappeared when the more popular Latin came into style. The only real remaining link to the dead language is the recently discovered Lavetta Stone. Unfortunately, most of the writing on it has been burned away or covered with petrified marshmallow droppings.

The presence of marshmallow on the Lavetta Stone indicates that the Polynesian Magma Man may have a taste for toasted marshmallows. Scientists have tried to exploit this fact by offering up the toasted treat as a sign of friendship. The problem is that their roasting sticks always end up bursting into flames, and the marshmallows drop into the dirty coals. This simply ends up enraging the Magma Man. Unfortunately, until communication can be established with the creature, unpredictable volcanic activity will continue, and beautifully toasted marshmallows will continue to be lost.

The Yasur Volcano on
Tanna Island, Fiji, prior
to the appearance of the
Magma Man.

The ancient Lavetta Stone.

The fate of every stick and
marshmallow offered to the
Polynesian Magma Man.

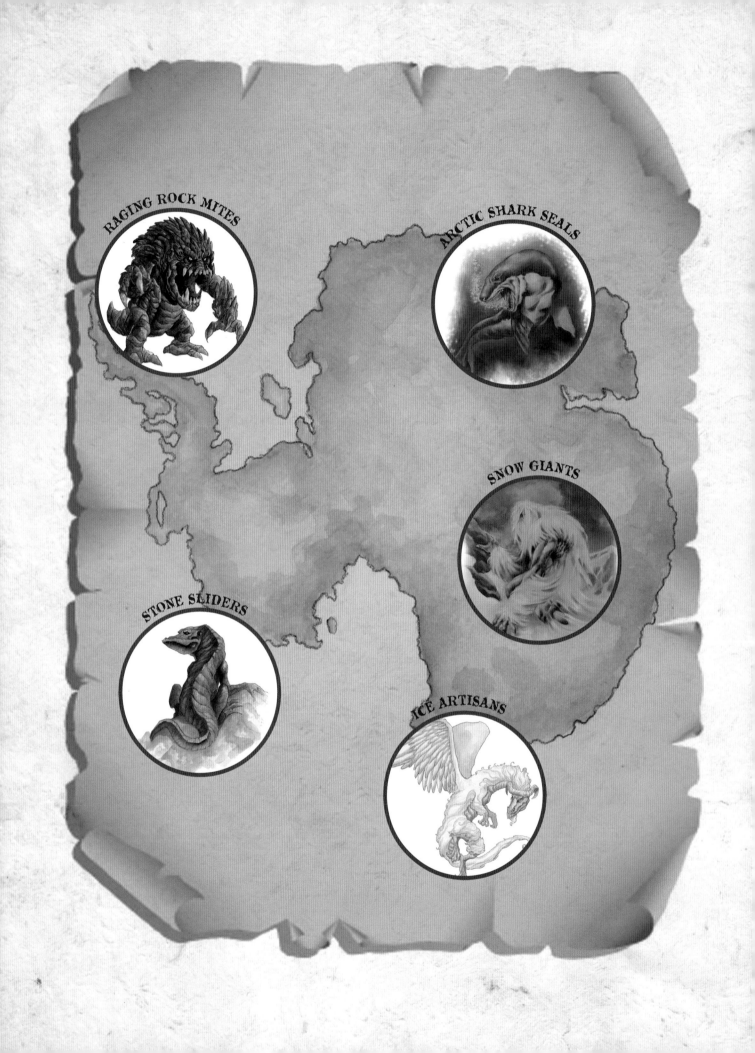

7

CHAPTER

ANTARCTICA

Ham Fabricatini's personal journal entry 7/20/2002

Since the United States government won't let me back in the country until I can prove I am disease-free, I have decided to catch a research boat from the southern tip of New Zealand to Antarctica. I'm not sure what I will find there, but I have some leads on a massive creature known as the Snow Giant. I'm hoping that on the trip over I can catch a glimpse of the legendary Shark Seal. There are rumors of other fantastical creatures as well, but at least there won't be any more mosquitoes!

*Jedediah Jedejones, one of the
original Miner '39ers and the
first human to encounter the
Raging Rock Mites.*

*The actual height of a
Raging Rock Mite is less
than a quarter of an
inch.*

*The remains of the shovel that
Jedediah used to strike the first
blow against a mite.*

RAGING ROCK MITES

MINER DISCOVERS BIG WORDS FROM TINY CRITTERS.

Raging Rock Mites were originally discovered by a small group of gold miners who called themselves the Miner '39ers (the name never really caught on) during the lesser-known Eastern Massachusetts Gold Rush of 1839, which only lasted for three days. Once the group realized there was no gold to be found in Eastern Massachusetts, the miners quit digging and decided to embark on a once-in-a-lifetime adventure: To mine for gold in the brutal, unforgiving land of Antarctica. The fact that gold had not yet been discovered there did not seem to deter them. It was shortly after their arrival that they discovered Raging Rock Mites.

Jedediah Jedejones, one of the '39ers, was breaking rocks in search of gold when he was verbally accosted by a tiny voice screaming at him from the broken rock. The profanity-laced tirade was coming from an insect-sized creature that was apparently upset over the greedy gold digger's intrusion.

Scared out of his wits, Jedediah took a shovel to the creature, but found its rock-hard skin to be a formidable match. Soon, dozens of the tiny creatures emerged and began biting and verbally abusing him until he ran from the quarry, screaming like a frightened schoolgirl.

Today, the area is fenced off, and only the strong of spirit and emotionally stable of the scientific community dare venture in to experience the verbal might of the these nasty mites. Researchers are still trying to determine whether the intrusion of the Miner '39ers started the Raging Rock Mites' caustic behavior, or whether they just come by it naturally. They don't appear to have any natural predator except for the Stone Slider (see page 127), yet the population never seems to increase. Scientists believe the reason is that they probably don't like each other enough to reproduce.

ARCTIC SHARK SEALS

IS IT A SHARK OR A SEAL?

One of the most intimidating predators of the ocean is also one of the least known. The Arctic Shark Seal is often overshadowed by the more-frequently photographed and well-known Leopard Seal. Although both are savage killers, it is the uniqueness of the Arctic Shark Seal that sets it apart from its competitor.

Physically, it appears to be a perfect hybrid between a seal and a great white shark, since it has the body of a seal but the distinctive markings of a great white. It also has multiple rows of razor-sharp teeth and can grow up to 18 feet in length. This left the scientific community to wonder: Is it a shark or a seal?

At first researchers believed it simply to be a rogue species of seal that became so jealous of the predatory might of sharks that they simply made themselves up to look like great whites. After a specimen was finally captured in the early 1900s, scientists discovered that the markings on the Shark Seal's coat, along with its toothy jaws, were authentic. The whole notion of a third party doing an elaborate makeup job was dropped. As Gunther Guunt, one of the examining scientists, told reporters concerning the Shark Seal's unique physical characteristics, "If a seal can look like a leopard, I suppose a seal can look like a shark."

Being ferocious meat-eating predators, Arctic Shark Seals seem content to feed on fish and the occasional really stupid "stick your head underwater to see what's there" polar bear. Remarkably, they leave the smaller native Arctic seals alone. The only time the two species come into conflict is on holidays, which clearly shows how closely they are related. Like seals, the Arctic Shark Seal gives birth to live young. The juveniles can often be seen congregating and fighting over the title "My Dad Is the Scariest." This type of youthful banter is productive in developing their aggressive predatory nature, and is preferable to sitting for hours in front of the ice floes, watching them drift.

The Arctic Shark Seal has a snout similar to a great white shark. The lack of a discernable ear supports the theory that their nostrils act as acute sensory devices.

Gunther Guunt, scientist and noted Arctic Shark Seal specialist.

A frightened juvenile Arctic Shark Seal, probably scared by one of its parents.

The Giants' teeth are all flat,
which makes them ideally
suited for their vegetarian diet.

The bottom of a Snow
Giant's feet are covered with
thick fur, which acts as both
insulation against the cold
and a protective pad for
crossing rough terrain.

The crew of the Lord Melville used
pies, much like this one, to replace the
snowballs used in their battles with
the Snow Giants.

SNOW GIANTS

LINGERING EMOTIONS REMAIN HIGH AFTER MORE THAN A CENTURY.

As previously mentioned, the Snow Giant is a close relative (second cousin) to the Reluctant Yeti (see page 98) with one big, noticeable difference: its enormous size. While Reluctant Yetis can grow to a height of 7 or 8 feet, Snow Giants can reach heights of 25 to 30 feet. Science has yet to uncover the exact reason for their giant stature, and since they are deathly afraid of needles, it is difficult to extract and analyze any genetic information from a living Snow Giant. Unfortunately, a dead Snow Giant has never been uncovered.

The giants often allow their hair to grow across their faces, which makes it difficult for outsiders to identify individual Snow Giants. This may be because, like the Reluctant Yeti, they enjoy their anonymity, or possibly because they just don't have any scissors. They also have strikingly brilliant blue skin under all of their hair. It's not clear why their skin is blue, although the best educated guess is that they are really cold.

Although Snow Giants are outgoing and generally personable, they have very little contact with the local sealers or research outposts. This apparently stems from the Great Snowball War of 1821. During the snowy season (pretty much year-round in the South Shetland Islands of Antarctica) the crew from the ship *Lord Melville* was stranded and forced to spend the winter on the islands. Some of the men waged snowball fights with the giants for recreation, but the giants always won because they could throw really huge snowballs. The crew quickly became disgruntled by the unfairness of the game. So when supplies finally arrived, they changed from snowball throwing to pie throwing. Frustrated, the Snow Giants quit playing because they were unable to make—or effectively throw—pies.

Now, Snow Giants seem content to hang out with the Reluctant Yetis when they come to visit, and they get their social recreation by providing outsiders with personal details about their cousins.

ICE ARTISANS

LOCAL ARTISANS SUFFER MAJOR BUSINESS SETBACK:
CAN THEY SURVIVE?

Ice Artisans can be found in any arctic region where ice is plentiful. They move through ice much like Stone Sliders (see page 127) move through rock. In fact, researchers have found that Ice Artisans sustain themselves by absorbing moisture from the air and freezing it upon ingestion. Over the years, it appears that some Ice Artisans have developed a taste for hot holiday drinks, such as hot apple cider and festive Tom and Jerrys. Although drinking a hot beverage causes almost instantaneous melting, the Ice Artisans still seem undeterred. It must be noted, however, that this self-destructive behavior is mostly limited to a very few thrill-seeking nonconformists.

Most Ice Artisans have shown that they are responsible and quite enterprising. The creatures were originally given their name because of their impressive natural ability to sculpt pots and decorative vases out of ice. They sold the articles to local human arctic dwellers and, in some cases, for hot holiday drinks. Their business was mildly profitable until the artisans started shipping their wares to the global market. Once the product reached a more temperate climate, it melted, leaving customers with nothing more than a soggy FedEx box. Outraged, consumers began demanding refunds, which nearly pushed the Ice Artisans into bankruptcy. A severe economic depression set in, along with unemployment, which some say may explain the hot holiday drink obsession.

Nowadays, most of the general Ice Artisan population seem content to live quietly in their remote arctic homes, peddling their frozen wares to any local who feels compelled to own an ice flower pot. However, some business-savvy Ice Artisans have begun to carve the occasional ice sculpture for weddings, proms, and department store openings.

A typical mail package that a consumer would receive with the purchased wares melted.

Ice Artisans create a wide variety of cold weather pottery and glassware.

A hot Tom and Jerry, the favorite drink of rebellious, or depressed, Ice Artisans.

This grumpy middle-aged man was once thought to be the Stone Slider's closest relative.

Pumice and obsidian are two types of volcanic rock that the Stone Slider cannot move through, as pumice is too porous and obsidian too dense.

Vitamin- and mineral-fortified cereal is the Stone Slider's favorite nonstone meal.

STONE SLIDERS

SCIENTISTS OUTRAGED OVER MISSING CHEERIOS.

The Stone Slider, or Rock Lizard, has the remarkable ability to move through solid rock as fluidly as a fish through thick water. The difference between the two lies in the Stone Slider's ability to alter its molecular structure so that it can merge with a stone and pass through it uninhibited.

Although the Stone Slider is essentially made of rock, ironically, it doesn't like to rock. In 1971 a scientist ventured outside his research facility to take soil samples near a rock formation. He brought with him a winterized 8-track tape player and was listening to a soundtrack from Woodstock when he noticed several Stone Sliders emerging from the rock formation and fleeing the area. At first it was believed the Stone Sliders just didn't like scientists, but it was later discovered that they had a sensitivity to loud rock music. This fact started rampant speculation that the Stone Slider might be closely related to parents over forty.

The Stone Sliders appear to be a gentle species that pose no physical threat to humans. In fact, they are actually beneficial. One of the favorite meals of the Stone Slider is the Raging Rock Mite (see page 119), a creature generally despised by most humans. Sliders also can absorb minerals and nutrients from the stones they live in. However, if their rock homes are deficient in the minerals they need, the Stone Sliders have been known to pilfer researchers' unattended cereal boxes—but only the ones fortified with at least eight essential vitamins and minerals. In some scientific outposts across Antarctica, the Stone Sliders have become a raccoonlike nuisance in their quest for cold cereal. Scientists are now recommending that anyone planning on having breakfast in Antarctica come equipped with an electric guitar—or, at the minimum, a portable radio tuned to a classic rock station.

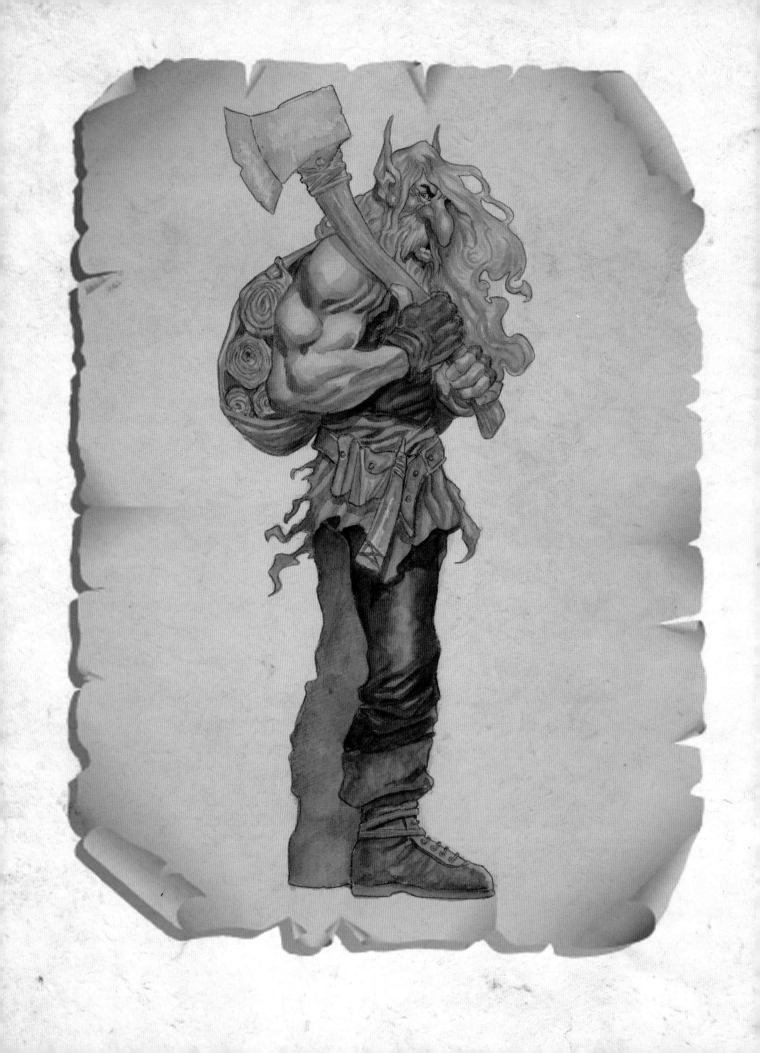

CHAPTER 8

DEVELOPING FANTASTICAL CREATURES

Taking ideas out of your head and making them come to life on paper is the most exciting part of being an illustrator. With a project like this, the artwork becomes as equally important—if not more—than the writing in determining its overall success. So now, let's take a close look at how I created the color art in this book.

BEFORE YOU BEGIN TO DRAW

Welcome to the How To part of this book. It was very important to me to include this section because of some of my past experiences that led to frustration. I remember as a young artist seeking out the works of great and famous fantasy illustrators like Frank Frazetta, James Bama, and Boris Vallejo. The treasures I found usually came in the form of paperback covers. As eye-catching as they were, the covers were, unfortunately, too small to study the artists' techniques. At that time there weren't really any publications available that explained how such talented artists created their beautiful works, which meant I was left to try and figure out what they were doing by myself, without any real understanding of what I was looking at.

I don't think there is anything more frustrating for a young artist or stalwart fan than discovering an artist whose work you enjoy and then not being able to learn how he or she created the images. So here I am, with my step-by-step process, to show you how I created the fantastical creature paintings in this book. Since there is no better place to start than at the beginning, let's start there.

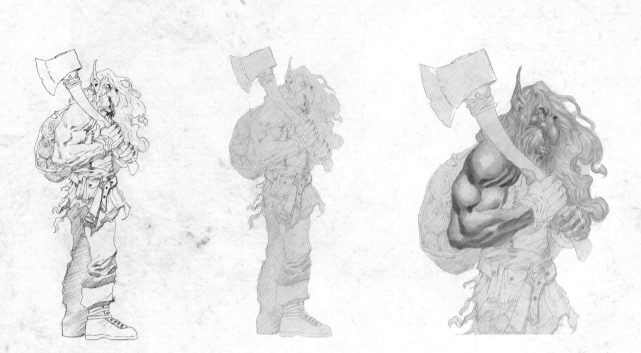

The first, and obviously most important, step is to develop the concept for an illustration (in the case of this book, a monster or creature). I get as many ideas out of the blue as I do from movies, books, and other illustrations. I read a lot of fantasy and science fiction, since most of my work falls within these two genres. I've also found a great deal of inspiration in children's books and classic illustrations, such as the works of Rockwell, Leyendecker, and Cornwell. When creating a character, you are limited only by the scope of your imagination. There are, however, a few guidelines you will want to consider. First, don't limit your ideas to the realm of practical thinking. Remember, there aren't any special effects or makeup budgets to worry about, so push your character idea in ways that are perhaps less predictable or conventional. In other words, try to come up with something that hasn't been seen a hundred times before. Next, try to understand who or what your character is *before* you begin drawing. Elements such as expression, environment, and accessories will play a big part in your drawing, and they must all work together to clearly define your character.

In the pages that follow, I will walk you through the steps I took to create the Appalachian Woodsman on pages 20–21.

STEP 1: DRAW AN INITIAL PENCIL SKETCH

I first drew an initial pencil sketch (left). However, after studying it I thought the face seemed too predictable and not unique. So, I came up with a new face that I felt was much more interesting (above).

STEP 2:
ADD DETAILS
IN PENCIL

Once I was pleased with the general
look of the character, I drew a tighter
pencil drawing. In this stage I fleshed
out the look of the character and added
details. I gave him more muscles, to
reflect his physical strength, and
made sure the axe looked accurate. In
addition, I added some accessories to
his belt. All of these details helped to
better define the character. I cannot
emphasize enough the importance of
the drawing. If a drawing is bad or
fundamentally flawed, no amount of
painting can cover it up. Likewise, a
great drawing can oftentimes over-
come mediocre painting technique.
Obviously, being proficient in both
areas is what you strive for, but as
the old adage goes: Never attempt to
run before you can walk. Gain com-
mand of your drawing skills first, and
then move on from there.

STEP 3: CREATE A COLOR SKETCH

When I was happy with the drawing, I moved to the precolor, or prepainting stage. The first step is to create a color sketch. A color sketch is exactly what it sounds like: A quick sketch using color to determine your color scheme for the painting, which you can use as a reference guide throughout the painting process. Before the advent of home computer technology, most artists would create a small, rough sketch of their finished illustration in pencil, and would then quickly paint it in. For my color sketch, I simply printed a small, black-and-white version of my pencil drawing and used watercolors to color it. If you don't have a clear idea of what colors you want, you can create several color sketches with different color combinations until you find the one that works best.

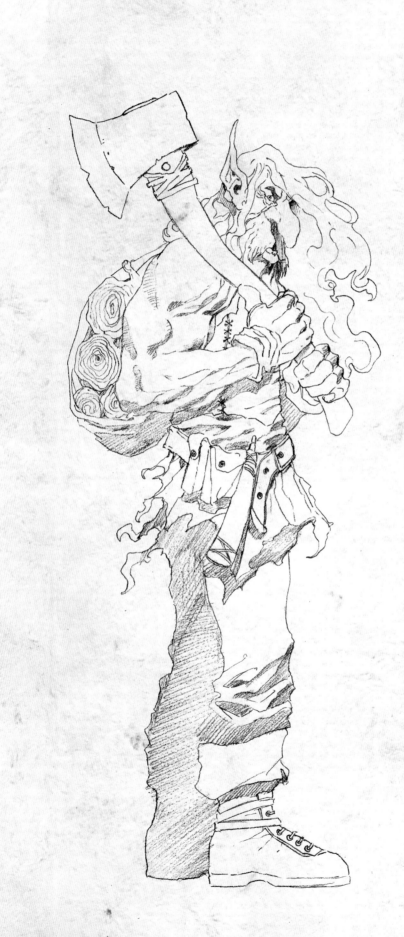

STEP 4: TRANSFER PENCIL SKETCH TO WATERCOLOR PAPER

Once I decided on my color scheme, I transferred my finished pencil drawing to watercolor paper. I use a light table to do this. If your finished pencil drawing is on a thick piece of illustration paper, you will need to print it out on a thin (20-lb or less) piece of paper so that the light from the light table can pass through it easily.

In this particular case, I drew the woodsman on a sheet of marker vellum, which is very thin paper. I placed the marker vellum on top of the light table and then placed my watercolor paper on top of the marker vellum. Once they were positioned, I traced the drawing. There are a variety of watercolor papers available on the market that vary in texture and thickness, so simply choose one that you like. There is no right or wrong option. (However, I will say I prefer to stay away from really smooth hot-press papers, as the paint tends to slide over the hot-press paper rather than being absorbed by the paper—which can lead to a muddy, over-worked look if you are not careful.)

After I made the tracing, I went back and lightly tightened up the drawing, adding some soft shading to indicate the light source. Do not try to establish the values (light and shadow areas) of your illustration using color as you paint. If you always determine the values first in the black-and-white or pencil stage, then you will find that the painting comes together much more easily.

STEP 5: APPLY THE BASE COLOR

At this point I was ready to start painting. I had already decided that my base, or key color, was going to be orange, with its complementary color, blue. (An explanation of color theory can easily comprise a book within itself. If you would like to learn more about this essential artist's tool, there are plenty of great books available on the subject, such as *Color Mixing Bible: All You'll Ever Need to Know About Mixing Pigments in Watercolor, Pastel, Crayon, Acrylic, and Oil* by Ian Sidaway.) Using Grumbacher tube watercolor paints, I painted a thin layer of orange over the entire figure. Because watercolors are transparent, orange will show through the other colors I lay on top of it, thus helping to maintain color harmony. If this piece had had a background, I would have painted it orange as well.

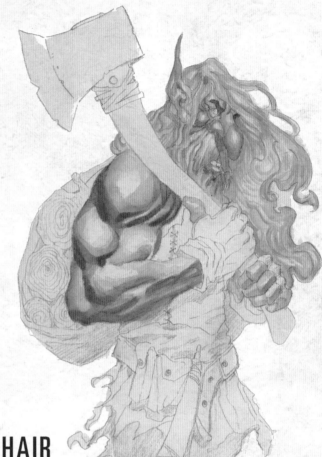

STEP 6:
PAINT SKIN TONES AND HAIR

Once the underpainting was completely dry, I started to paint the parts of the figure that would have similar colors. In this case, I started with the flesh tones and hair. For the skin, I used a combination of orange, raw sienna, and light touches of cadmium red hue. In the shadow areas, I used light touches of mauve (a terrific color for flesh tones) and indigo blue, along with raw umber. For the hair, I used Naples yellow, with orange and raw sienna for the darker areas.

The key to watercolor painting is to lay on the color without having it bleed or become muddy. I lay down brushstokes of color, starting from the edge of the figure and working my way toward the highlight. Once I lay down a brushstroke, I immediately wash out my brush, tap off the excess water, and run it along the edge of the initial color brushstroke to soften the edge or blend the color into the white of the paper. If I want the initial color brushstroke to have a hard edge, I just leave it to dry as is.

It is important to make sure that the brush is not too wet when you are applying the paint. If it is, the color will bleed, and you will get a sloppy, amateurish look to your painting. I also prefer to use light, thin color strokes so that I can slowly build up the color on the paper. This gives me more control and makes mistakes minor and easy to correct. Remember, it is imperative that the first color stroke be dry before you lay down another brushstroke. Therefore, instead of waiting for the color to dry, I use a hair dryer to quickly dry the paint and paper. Using this approach allows me to build up color, applying layer on top of layer of color until I attain a deep, rich look to the painting. I usually wait to add the darker shadow colors at the end, because I don't want those colors accidentally bleeding into the lighter areas.

STEP 7:
PAINT PANTS
AND VEST

After I finished the skin tones and the hair, I continued to paint similar color areas, one at a time. First, I used burnt sienna with orange for the highlights in the pants and vest, and then applied raw umber for the darker areas.

STEP 8: PAINT TATTERED SHIRT

I then used sap, or olive green, for the tattered shirt wrapped around his waist, and indigo blue for the darker shadow areas. To create three-dimensional volume, the darker shadow area must lie next to the lighter color it contrasts. The area closest to the light source should be the lightest (highlight). As the form curves away from the light source, it should gradually become darker (midtone) until it becomes the area farthest away from the light (shadow). Regardless of what you are painting, these principles apply to any surface.

STEP 9: PAINT ACCESSORIES

I used raw umber with orange for the gloves, boots, belt, and axe handle, and burnt sienna for highlights. I built up the color with the same techniques discussed in steps 6, 7, and 8. As you build up color, it is important not to encroach too much onto the highlight areas, because you do not want them to become too dark and lose their three-dimensional volume.

STEP 10: ADD SHADOW AREAS

I then added indigo blue to all of the shadow areas and the axe head. If the shadows appeared too blue, I added raw umber on top of them to bring the color intensity down a bit, making it grayer. It is important to note that warm colors lean toward orange and that cooler colors, and shadow areas, lean toward blue. This maintains the original color scheme and creates harmony for the overall piece.

STEP 11: OUTLINE THE FIGURE'S DETAILS

This step is really twofold. First, you will notice I used a brush to darken some of the interior line work on the figure, specifically around the eyes and nose of the woodsman and anywhere else I felt needed separation (notably the axe handle, belt, and the edge of the tattered shirt).

Second, once all of the inner detail was complete, I took a blue colored pencil (the complement of orange) and outlined the entire figure. This step is uncommon in watercolor paintings, but because of my comic book art background, I like the look of a solid line around a figure. It removes the soft edges and pulls everything together.

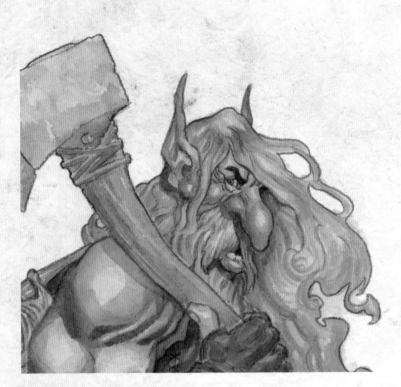

STEP 12: CHECK ALL THE COMPONENTS

I always like to put my painting away for at least a day or two and then take another look at it to (1) make sure I didn't overlook a mistake and (2) make sure all the components still work for me. In this case, unfortunately, I found something wrong (left): I forgot to draw and paint the woodsman's left ear! It took me only a few minutes to pencil in the ear and paint it (above). I would have been really upset if the picture had been printed with this mistake. Although this is a type of error I ideally would have liked to fix in the pencil stage, thankfully I was able to catch it and fix it.

Well, there you have it. This is the process that I followed on every watercolor painting in this book. I would not be so presumptuous as to say this is the right way to approach and complete a painting, or even that it is a good way. It is simply *my* way. I hope this helps any fledgling painters—or is at least a source of amusement to seasoned professionals.